Adobe Photoshop Lightroom 1.1 for the Professional Photographer

David Huss
David Plotkin

ELSEVIER

AMSTERDAM • BOSTON • HEIDELBERG • LONDON • NEW YORK • OXFORD
PARIS • SAN DIEGO • SAN FRANCISCO • SINGAPORE • SYDNEY • TOKYO
Focal Press is an imprint of Elsevier

Focal
Press

Focal Press is an imprint of Elsevier
Linacre House, Jordan Hill, Oxford OX2 8DP, UK
30 Corporate Drive, Suite 400, Burlington, MA 01803, USA

First published 2008

Notice
No responsibility is assumed by the publisher for any injury and/or damage to persons or
property as a matter of products liability, negligence or otherwise, or from any use or operation
of any methods, products, instructions or ideas contained in the material herein. Because of rapid
advances in the medical sciences, in particular, independent verification of diagnoses and drug
dosages should be made

British Library Cataloguing in Publication Data
A catalogue record for this book is available from the British Library

Library of Congress Cataloging-in-Publication Data
A catalog record for this book is available from the Library of Congress

ISBN: 978-0-240-52067-4

For information on all Focal Press publications
visit our web site at www.focalpress.com

Typeset by Charon Tec Ltd (A Macmillan Company), Chennai, India
www.charontec.com

Printed and bound in Canada

07 08 09 10 11 10 9 8 7 6 5 4 3 2 1

CONTENTS

Introduction ... viii

Acknowledgments .. xi

Chapter 1 In the Beginning ... 1

Stop – Reading Begins Here 2

Lightroom: A Brief History .. 2

What's New in Version 1.1? 3

Workflow? What Exactly Does Lightroom Do? 6

Does Lightroom Replace Photoshop? 6

What Makes Lightroom Different? 7

Hardware and Performance 8

 The Need for Speed .. 8

 Mac vs. PC ... 8

 Video Graphics Cards ... 8

 Thanks for the Memory 10

 How About My Wacom Tablet? 11

 What's the View of Windows Vista? 11

 Networking and Shared Resources 11

One Program – Five Modules 12

Navigating and Managing Lightroom 12

 Main Menu ... 13

 Top Panel ... 13

 Grid View or Image Display 13

 Toolbar .. 14

 Right Panel ... 14

 Left Panel ... 15

 Filmstrip .. 15

 Where is the …? .. 15

 The Power of Keyboard Shortcuts 16

Contents

Chapter 2 Getting Photos into Lightroom...23

From the Camera to Lightroom...23

　　Setting Up Import Settings...24

Stop Before You Do Anything Else...26

Importing Photos ...28

Importing Images via Drag and Drop ...34

Lightroom Speed Bumps...34

　　Import Results ...34

Sorting the Good, from the Bad, and the Ugly ...36

Comparing and Rating Your Photos ...38

　　Rating Your Photos – So Many Ways...41

　　Working with the Stars...42

　　Flags – Simple and Effective...43

　　Working with Color Labels...44

　　Filtering the Results...46

　　Finding Photos Without Color Labels ...48

　　Viewing the Results ...49

Chapter 3 Organizing Your Photos...51

Lightroom Image Management Concepts...52

　　Stacking Photos ...52

　　Collections and Quick Collections...56

The Power of Keywords ...59

　　Adding Keywords to a Photo ...60

　　The Painter tool that Doesn't Paint ...65

　　Keyword Searching...67

　　Metadata Browsing...67

Exporting and Importing Catalogs ...68

　　Exporting a Catalog...68

　　Importing a Catalog ...69

　　Lightroom and Network Shared Drives...74

　　Where Lightroom Keeps its Files (Windows)...75

　　Where Lightroom Keeps its Files (Mac) ...75

**Chapter 4 Pursuing Perfection: Working with the
Quick Develop and Develop Module...77**

Unleashing Quick Develop...77

Quick Develop ..78

 The Tone Controls and What They Do................................86

The Develop Module...90

 Interactive Histogram ..90

 Using the Compare View ...91

 Fine Tuning the White Balance91

 Tone Curve Panel...93

 Split Toning...96

 The Power of Presets ..99

Retouching and Correcting Flaws101

 Crop, Straighten, or Both ..101

 Getting the Red Out ...106

Chapter 5 Showtime: Making Slideshows 109

Understanding the Slideshow Module..............................109

Selecting and Setting Up for Slideshows...........................110

 Selecting Photos for the Show110

 Configuring the Stroke Border111

 Specifying the Shadow ...112

 Showing and Adjusting the Guides............................114

 Applying a Color Backdrop......................................114

 Adding a Background Image116

 Zooming to Fit Frame ...118

 Adding and Editing the Identity Plate119

 Adding Star Ratings to Your Slides............................122

 Adding Text to Slides Using Overlays.........................122

 Adding a Sound Track...126

 Saving it all as a Template..127

Playing the Show ...129

 Specifying the Slide Duration129

 Viewing the Preview..129

 Viewing the Slideshow ..130

 Exporting the Sildeshow ...131

**Chapter 6 Roll the Presses: Printing in Adobe Photoshop
Lightroom ..133**

Understanding the Print Module...........................133

Contents

Selecting and Setting Up for Printing 133

 Selecting Photo(s) to Be Printed.. 134

 Configuring the Stroke Border.. 134

 Setting Units of Measure, Guides, and
 Showing Rulers .. 134

 Opening the Page Setup Dialog... 136

 Dragging or Setting Margins for Border Control......... 137

 Zoom to Fill Frames.. 138

 Auto-Rotate to Fit .. 138

 Adding Text to Photos Using Overlays........................... 140

Printing Multiple Photos on Single Sheets......................... 141

 Setting Rows and Columns .. 142

 Printing the Same Photo Multiple Times on
 the Same Page .. 143

 Making a Contact Sheet ... 143

Saving It All as a Template .. 144

Configuring for Printing .. 145

 Using Color Management... 145

 Using the Set Profile Dialog Box....................................... 146

 Setting the Rendering Intent... 147

 Setting Up the Print Job ... 147

 Setting Up for Printing (Printer Dependent)................. 148

**Chapter 7 Web Wizard: Creating and Posting
Images on the Web .. 151**

Understanding the Web module .. 151

Selecting and Setting Up for the Web.................................. 153

 Selecting Photo(s) for Your Site... 153

 Choosing Between Flash and HTML Galleries 153

 Setting the Site Info... 154

 Adding an Identity Plate... 154

 Configuring the Color Palette.. 155

 Setting the Web Page Appearance 156

 Adding Image Info ... 161

 Setting Up the Output.. 161

 Saving it all as a Template.. 162

Previewing and Exporting Your Photo Gallery................... 162

 Previewing Your Gallery in a Browser.............................. 163

 Exporting Your Gallery... 164

Posting Your Photo Gallery 164

 Configuring Your FTP Settings............................. 165

 Performing the Upload 166

 Extra Stuff You Need to do on Your Web Site 166

 Providing a way to return to your main web site......... 167

Index .. **169**

INTRODUCTION

This is a book for photographers who can read the users guide that came with Adobe Photoshop Lightroom 1.1 and do not need me to tell them what they can figure out for themselves. The Lightroom User Guide and online help file contain a wealth of information which I have used many a time myself. There is some misinformation that is still left over from the 1.0 release, but Adobe is working hard to get it all updated for the latest release.

The focus of this book is all about using Lightroom 1.1 in a working environment. While most of my photography involves shooting stock or weddings, many of the tips and suggestions in this book came from dozens of 1.1 beta testers working in a variety of photo occupations who were gracious enough to answer my seemingly endless stream of questions about how they use Lightroom in their own work, or how they worked around some perceived limitation of the current release of Lightroom. Some parts of the material covered in our book are based on questions that appear on Adobe's User 2 User forum. If a question keeps getting asked by different people, then there is something about how Lightroom works that isn't as simple as it seems.

As you flip through the pages, you may notice Windows and not Mac shots. We have nothing against the Mac, but both authors are hard core Windows users (XP by the way; Vista is still my operating system of choice to slow down even the fastest computer system).

Managing Digital Images

My favorite scene in the Walt Disney's original *Fantasia* is *The Sorcerer's Apprentice*. I am referring to the scene in which Mickey conjures brooms to do his job of carrying water only to quickly discover the brooms are producing too much water. Soon he is trying to keep his head above water while at the same time attempting to get the brooms under control. That scene serves as a wonderful metaphor of image management for many digital photographers today who are trying to manage an ever growing sea of photos while at the same time attempting to structure a workable image management system. In other words, if image management for your business has been something akin to herding cats, you are not alone.

DAM Terminology

If you shoot weddings or portraits using a digital camera, you have a digital asset management (DAM) system. It may be as simple as a system of folders and sub-folders you maintain on your computer or a sophisticated software

application like Extensis Portfolio. Whatever you currently use, your goal should be to find the best way for integrating Lightroom into a workflow that works best for you with minimal loss of investment in your DAM solution.

Needles in Haystacks

There are many tools for managing images in Lightroom. As with all of the tools in Lightroom, it is important to remember that just because a tool is there it doesn't mean you need to use it. I am told that less than 10% of the functions on a scientific calculator are ever used by its owner. The key to making Lightroom work for you and your business is discovering and applying those tools that you need and having the freedom to, at least for the moment, ignore the rest.

Regardless of the tool or system of tools that you use, the ultimate goal will be the same – to be able to quickly locate a particular photo in a collection.

True Confessions: As an author I am required to keep track of hundreds of screen shots while I am writing a book. A few years ago one of my books was being prepared for reprint. The publisher (not Focal Press) notified me that they had lost some of the original art and asked me to resend them the originals. I thought I knew where they were kept but as I went through the folder where they should have been I recalled that I had to recapture several of them. Murphy's Law being a constant in the universe, those recaptured were the images that were not in the folder. In the end I had to recreate the missing art which took several days. Had I used an image management system and backed it up routinely, it would have taken less than five minutes. Lesson learned.

Mass Production

As you begin to work with the tools within Lightroom, you will discover the ability to synchronize all of the adjustments that you made to one image to several, even hundreds, of others. This means that you can spend extra time getting the colors and tonality just perfect and then apply it to all of the others shot under similar lighting conditions.

Intuitive vs. Study

One of the advantages of Lightroom is also a liability. It is so well designed that even a caveman can use it. I apologize to any caveman who might be offended by that remark. It is because it is so easy to figure out that many of us get lazy and don't take advantage of the powerful tools in Lightroom. Don't be one of those users who only skim the surface of the application. Spend some time and explore Lightroom. If you open a menu and there is a command that you don't recognize, use the Help feature and find out what it is and what it does. As you dig deeper into the program you will begin to accomplish tasks that even the program designers had not envisioned.

Beyond This Book

Even though Lightroom is a new program, there is already a wealth of web sites that provide extensive resources in the form of tutorials, free templates, examples, and galleries. These provide valuable information about how others are using Lightroom and what they are doing with this amazing application. You can use www.google.com to look up these sites. Here are a few of my favorites: www.lightroomkillertips.com, www.photoshopsupport.com/lightroom, www.lightroom-news.com, www.seanmcfoto.com/lightroom, and www.photoshopuser.com.

ACKNOWLEDGMENTS

And the winner is… If you have ever watched an award program like the *Academy Awards*, you know that after the winner is announced the recipient reads off a list of all of those unknown people who helped make this golden statue theirs. The acknowledgments section of this book is very much like that – an often endless list; the main difference, however, is that you can skip past this section while during the Awards ceremony you must wait until they finish or the music begins to be heard indicating that their time is up.

The fact is, whether you know the names or not, those people mentioned are directly responsible (or to blame) for the book you are holding. So who reads this section? Those that are mentioned or at the very least think they should be mentioned. To list everyone who had a part in the creation, design, and production of this book would create several pages that would look like the credits of a movie – which can last as long as ten minutes. Therefore, we will just hit the highlights and for those that I unjustly missed, I begin with an apology.

First and foremost is Mark Hamburg, Adobe Fellow, former Photoshop architect, and founder of the Lightroom project. Without Mark this program wouldn't have come to pass. Tom Hogarty is another of the many members of the Lightroom development team that endured the slings and arrows of frustrated testers as the application evolved as they daily proved the adage that you can't please everyone. Thomas Knoll, one of the original creators of Photoshop, should also be mentioned but he has already had so many accolades heaped upon him let's give him a break and not mention him – except I just did. Vishal Khandpur is one of the many unsung heroes who have worked tirelessly to manage the beta programs on Adobe's prerelease site and his efforts have resulted in some of the smoothest beta testing cycles I have ever experienced.

Many of the Lightroom beta testers were fantastic sources of information during the development cycle. Again, space does not permit naming them all but a few stand out from the rest of the herd. Jeffrey Friedl, Lee Jay Fingersh, Sean McCormack and Roy Nuzzo have all at one time or another solved a mystery or pointed me in the right direction as the product evolved from 1.0 to 1.1 to 1.2 – many thanks.

Thanks also go to David Plotkin, who came to my rescue when my schedule and health collided and he was able to take over the writing responsibilities for several of the chapters.

For Focal Press, thanks go first to Marie Hooper who must bear most of the blame for having me write a book about Lightroom. A major co-conspirator in this operation is my editor Valerie Geary who has had the unenviable job of trying to keep me on schedule which is much akin to herding cats. Thanks to the production team at Focal Press who turned a bunch of words and screen shots into the book that you are now holding.

I also want to thank my… (music begins to be heard in the background), well I guess I am out of time. I also want to thank my wife… (music gets even louder) and my family without whom… (music approaches deafening levels). You know the rest.

Cheers
Dave Huss

I also want to thank Valerie Geary, but for a different reason – she was very supportive and made sure I had everything I needed to produce quality work and stay on deadline. Not an easy job, let me tell you. And, of course, I must thank my wife Marisa, who supports these projects even when she doesn't understand what the software does. She knows it makes me happy to write these books, and that is enough for her.

David Plotkin

CHAPTER 1

In the Beginning

I thought it is best to begin this book on a dignified tone with a short history of where Lightroom came from. Every word of the following epic is the truth – give or take a lie or two. It works best if you imagine it being read by James Earl Jones.

In the beginning, there was Photoshop and it was good. But soon the scribes of photos began to partake of the digital camera and they became restless. Forsaking the film of their fathers, they began creating digital photos as if they were free. Soon digital photos began to multiply throughout the land. Thomas Knoll and Mark Hamburg looked down from Mount Adobe upon the photos wandering about the hard drives and said they need someone to lead them to the Promised Folders lest they be lead astray by a false prophet.*

Then a light shone from on high and behold, there was Lightroom. The photo scribes were awed. They beheld its simplicity and beauty and said it was good. Soon all of the photos were rejoicing in their workflow and so it came that on the seventh day of the seventh month of the last beta, the entire development team said 'Behold, our labors are complete and 1.0 has shipped.'

*Some of the earliest ancient manuscripts include 'and the name of the false prophet was Aperture.'

But lo a voice from on high was heard to say 'Version 1.1' and the team returned to their labors.

Stop – Reading Begins Here

The title of this section may seem a no-brainer, but so many readers want to get working as soon as possible and they skip over some important stuff they will be trying to find later on and to that extent I hope I will get at least some readers to pause, review the topics covered in this chapter, and possibly absorb some vital information lurking there.

The biggest challenge facing any author is how to transfer all of the information necessary to use Lightroom in the least amount of time. If you are a working photographer, you probably don't have the time to sit back and digest several hundred pages of material before being able to use a program that itself is relatively easy to use. Therefore, the goal is to find a way to get the Lightroom information that you need to get up and running with the minimum amount of pain. Between us we have written over 30 books, we have developed a lot of theories about the best way to do it – none have worked to date, but hope springs eternal. Clearly, the easiest way to get you, the reader, the information is to use the Vulcan Mind Meld; it's quick and painless but it turns out that there are a lot of privacy issues attached, so that plan had to be abandoned. If you don't know what the Vulcan Mind Meld is, well … ask your dad– sigh.

Back to our mutual challenge of getting the information, you need to use Lightroom without making you read the entire book, from cover to cover. The solution is to divide the book into free-standing parts, so that you can quickly turn to the section that deals with the topic you are attempting to master, read the brilliantly written, concise explanation. It is not our intention for you to cozy up by a warm fire and read the book from cover to cover. You can do that if you want, but if you do it is a sure sign that you are not dating enough. If we do our job right, 1 year from now, this book will have dog-eared pages and taco stains on the cover.

Lightroom: A Brief History

Photoshop Lightroom is a software workflow tool designed by and for photographers. What about Photoshop you might ask? It is instructive to know that when Photoshop was created, digital cameras were nothing more than laboratory toys and scanning photos into digital images was an expensive process. Over the years Adobe has continually improved Photoshop but there is only so much you can change. What was needed was an entirely new application designed from the ground up as a tool for working photographers. This is the driving purpose behind the creation of Lightroom. In a bold stroke, the folks at Adobe shed their traditional cloak of secrecy and allowed the entire world to participate in the creative process by releasing the product as an open beta early in the development cycle. Anyone could download, use, comment,

complain, or make suggestions as to how the program should work and comment they did. Each beta release of the software saw it change shape, form, and function. Around November 2006, Adobe ceased posting new versions of Lightroom with the Beta 4 release but continued tweaking and updating the product to a limited number of beta testers. I only mention this because those users who became accustomed to the beta 4 version of Lightroom were a little surprised when they saw the 1.0 version that was released in February 2007. Many testers had a long list of things that they strongly felt were missing in the 1.0 release and so Adobe continued tweaking, renaming, and adding even more features until they finally released the 1.1 version.

What's New in Version 1.1?

Here is a brief and incomplete summary of what is new in Lightroom Version 1.1.

- *Create and open catalogs*: A catalog is how Lightroom tracks the location of files and remembers information about them. A catalog was called a library or library database in Lightroom 1.0 which leads to instructions like opening a library in the library module. In Lightroom 1.1, the terminology has been changed and greatly improved.
- *Import and export catalogs*: Export a group of selected photos as a new catalog or import photos from another catalog into an existing catalog. In the opinion of many, this is probably one of the biggest improvements (**Figure 1.1**).

FIG 1.1 The importing and exporting of Catalogs is a big improvement in Version 1.1.

- *Synchronize folders*: Synchronizing folders provides the option of adding files that have been subsequently added to the folder but not imported into the catalog, removing files that have been deleted, and scanning for metadata updates. The photo files in the folder and all subfolders can be synchronized. You can determine which folders, subfolders, and files are imported (**Figure 1.2**).

FIG 1.2 The ability to synchronize folders is a powerful new feature of Version 1.1.

- *Enhanced digital negative (DNG) export settings*: DNG file creations now support the full set of conversion options. You can specify the JPEG preview size, select an image conversion method, specify a lossless compression, and determine whether to embed the original camera raw file. Lightroom lets you update the DNG preview on request.
- *Additional metadata fields and presets*: The Metadata panel includes new options for large captions and location. The panel also includes new options for email, URLs, and more. You can perform many actions, such as resolving metadata conflicts and opening a folder, by clicking the buttons to the right of the metadata fields.
- *Hierarchical template folders*: Template panels now let you create additional folders with parent–child relationships. For photographers with a growing number of develop, print or web presets, this folder structure provides additional options for organizing photos. You can also store presets with the catalog file for easy mobility (**Figure 1.3**).
- *Painter tool*: Don't get excited just yet, the Painter tool doesn't have anything to do with painting. In Lightroom 1.0, you applied keywords to multiple images in Grid view by using the Keyword Stamper tool. In Lightroom 1.1, the Painter tool replaces the Keyword Stamper tool. Not only can you use the Painter tool to apply keywords to photos, but you can also apply labels, flags, ratings, develop settings, metadata, and rotation settings. You can click photos or drag across them as if painting (**Figure 1.4**).

FIG 1.3 Hierarchical folder strcture improves template organization.

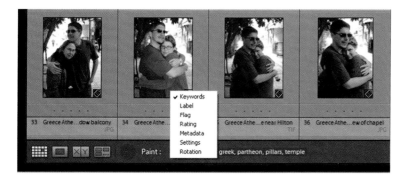

FIG 1.4 Version 1.1 renamed the Keyword Stamper tool and made it more versatile

- *Remove Red Eye and Remove Spot tool enhancements*: In Lightroom 1.1, the Remove Red Eye tool has been improved to make it easier to detect and remove red eye. The Remove Spot tool has also been improved to make it easier to repair blemishes in photos.
- *New develop settings*: In the Develop module, noise reduction and sharpening tools have been improved, and the Basic panel includes a new clarity control for adding extra 'punch' to your images. OK, they're not as good as some of the tools in Photoshop, but it is a lot closer than it was in 1.0.

Workflow? What Exactly Does Lightroom Do?

Lightroom is the equivalent of a Swiss Army knife for digital photographers (**Figure 1.5**). It has a huge mess of tools neatly packed into a single package. In addition to instantly making several hundred dollars disappear from your bank account when you bought it, Lightroom imports, previews, performs tonal corrections, color correction, sensor spot removal, red-eye removal, straightens (are you still reading this?) and it also makes slideshows, and creates really cool web pages, just to name a few. I can see a little cloud forming over your head as you read this. What about my existing photo editor? In other words…

FIG 1.5

Does Lightroom Replace Photoshop?

This is probably the most asked question since the introduction of Lightroom. Adobe and others have been consistent in their politically correct answer '… Adobe Photoshop Lightroom is the perfect complement to Adobe Photoshop.' That answer is correct, but it is also very narrow especially when you consider that there are other Adobe applications that need to be considered when looking at what replaces what. Most users of Adobe digital imaging solutions know there is more than one overlapping solution in the Adobe library of applications. In addition to Photoshop, there is Adobe Bridge which has evolved from a modest inter-application utility into use as an image manager by many Photoshop users. Let's not ignore Photoshop Elements which, like Photoshop, has all of the necessary tools that Lightroom does not.

So, does Lightroom replace Photoshop, Bridge, or Photoshop Elements? The answer depends on what you do. Wedding photographers I interviewed during the Lightroom beta testing told me Lightroom does everything they need for a wedding shoot and does it in the least amount of time and time is money. For myself, I shoot stock and fine art photography, so Lightroom is not enough to do all of my magic; so I need an external photo editor like Photoshop or Photoshop Elements for a few of my special photos. So, while

Lightroom won't replace your existing favorites, it will change how and when these programs are used.

What Makes Lightroom Different?

Probably the biggest feature of Lightroom that makes it different from the rest of the digital imaging herd is its ability to make adjustments to images while leaving the original photo untouched whether you are working with Raw images, JPEG, TIFF, or even Adobe DNG. This is a very important concept, so I thought it is best to include an example.When working on images with a traditional photo editor, you want to preserve the original image so that you can return to it after the client tells you that what they asked you to do isn't what they meant at all. Isn't communication fun? The duplicate image method is the best way to ensure that you always have a copy of the original to return to. It also fills up the hard drives pretty fast. The Lightroom approach is to apply the changes to a small file called a sidecar file that is kept with the image. When the file is displayed in Lightroom, the image displayed reflects the changes you made. The original remains untouched.

There's more. Back to Photoshop, if you wanted to make several versions of an image treatment to show a client, it requires multiple copies of the image. In Lightroom you can make a Virtual Copy of the image. While it appears that there are multiple copies of the image, there is actually only one with multiple sidecar files reducing the amount of hard drive space needed. The example shown next is a photograph of a couple of Cuban cigars (it's legal to look at them, you just can't bring them into the US) (**Figure 1.6**). It appears that there are three identical photos showing several different treatments. The original file size is 15 MB, but, even though there are three different variations (you can only see three of the variations in the figure), the total file size is still roughly

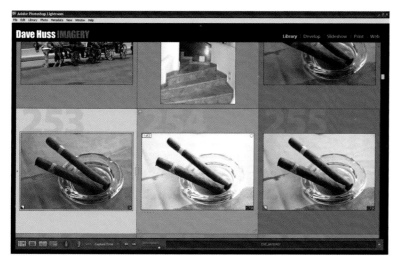

FIG 1.6 Virtual copies allow

FIG 1.7 Two processors are better than one, but they don't make Lightroom run twice as fast.

15 MB. Had I done the same thing in Photoshop, the total of the four variations would have been over 60 MB.

Hardware and Performance

Lightroom is a cross platform application, meaning that there is one program that can be installed on either a Mac or a Windows platform. For the Mac users, Lightroom is written in Universal Binary, so it can go blazing fast on an Intel-based Mac without the need of Rosetta as well as work on a G4 or G5 (**Figure 1.7**).

The minimum hardware requirements are printed and posted everywhere so rather than wasting space repeating them, I will instead give some recommendations about what equipment will improve Lightroom performance and what won't.

The Need for Speed

Like most image editing applications, getting a faster processor will have a minimal improvement in the speed of operation. For example, on a Windows platform, doubling the processor speed may produce a 20% increase in performance. According to Apple, upgrading from one of the Power PC chips (G4 or G5) to the Intel-Duo chips will double the speed. Will that actually make Lightroom work twice as fast? Probably not since a significant part of Lightroom operation involves disk accesses, and hard drives (even the latest, fastest ones) are a bottleneck. What about dual processing on a Windows platform? Good question, and the only answer I can give you is comparing the performance of a system with an Intel P-4 vs. a similar system with the Intel-Duo. Casual testing indicates no notable difference in performance between the two (**Figure 1.8**).

FIG 1.8

Mac vs. PC

The eternal question was often brought up during 1.1 beta testing – most of whom were Mac users. For lots of technical reasons, the Mac has a slight performance edge over Windows (especially if you are using Windows Vista). Mac OS X seems to manage memory better than Windows and the graphics language selected to work with Windows turned out to be less than an optimum choice. Regardless, the difference between running Lightroom under OS X and Windows isn't great enough to warrant further consideration (**Figure 1.9**).

Video Graphics Cards

The video graphics card, also called graphic accelerator, is a piece of hardware (often quite ex pensive) that seems like it should speed up all of your image

FIG 1.9 Powerful graphic processors like this ma speed up your favorite video game but will not improve Lightroom performance.

editing. Actually, these cards are designed to speed up video games and editing movies. And they do not provide any improvement when used with Lightroom, Photoshop, or Photoshop Elements. I am not saying that you can't buy some hot graphics card to feed your video game habit and say that it is for improving Lightroom, I am only saying you shouldn't expect to see any difference in performance – with Lightroom. In the first two paragraphs, I have shot down processor speed and graphic cards. You may be wondering if there is anything you can do that makes Lightroom run faster. Never fear, when it comes to computers there are always ways to spend money and improve performance – like increasing the amount of random access memory (RAM) on the system (**Figure 1.10**).

FIG 1.10 Memory is the one piece of hardware that will always improve Lightroom performance.

Thanks for the Memory

Lightroom loves RAM, lots and lots of RAM. The truth be known, all photo editing applications can benefit from extra RAM. There are some natural limits to the amount of RAM you can stuff in your computer, like the maximum amount of RAM that your computer can hold, as well as how much RAM the operating system can effectively use. In addition to these limits, there are several factors that affect how much RAM Lightroom needs. One determining factor is the size of the camera image you are shooting. The size of the raw image produced by a 10.2 megapixel camera has greater memory needs than a camera with a 5 megapixel sensor.

As a general rule of thumb, anywhere from 1.5 to 2 GB of RAM is a good amount of memory for almost any image editing application. Many users view RAM in the way they treat vitamins. If a little is good, more is better. Just because your system allows the installation of large amounts of memory like 4 GB, don't immediately assume that you need it. Once you get beyond 2 GB in RAM, those reasonably priced memory modules suddenly become very expensive. Before making the leap, check out your memory usage while the application is running. In Windows, press Ctrl+Alt+Del and look at the Performance tab. In the example shown, only half of the 2 GB installed on the system is being used. If the memory on this particular system were doubled to 4 GB, the amount of RAM used by Lightroom would not change, and I would have paid more money for the fatter RAM modules than I paid for the original computer (**Figure 1.11**).

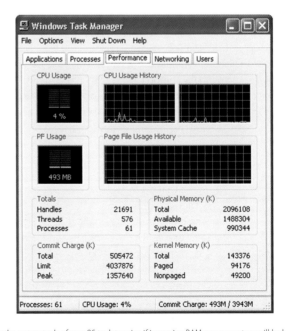

FIG 1.11 Use the system tools of your OS to determine if increasing RAM on your system will be benefical.

For Mac OS X 10.3, 10.4 or later, open Activity Monitor (/Applications/Utilities/). For Mac OS X 10.2.8 or earlier, open ProcessViewer (/Applications/Utilities/).

Mac OS X processes and applications are listed in main window. In Mac OS X 10.3.9 and earlier, the '% Memory' column indicates the percentage of RAM in use by an application or process at the time of sampling.

In Mac OS X 10.4 or later, you can see the overall percentages of memory in use or idle at the bottom of the Activity Monitor window.

How About My Wacom Tablet?

Sorry, but in this first version of Lightroom, none of the tools use the pressure-sensitive features of the Wacom tablets. No great loss really since there is only one tool that could possibly take advantage of the pressure information. You should still have a Wacom tablet attached to the computer for use with your image editor. Lastly, yes there are other companies that make wireless pressure-sensitive tablets, but Wacom makes the best ones, so accept it and don't send Focal Press emails complaining about it. Instead, send emails to Adobe saying you want them to add tablet support in the next release of Lightroom.

What's the View of Windows Vista?

Windows Vista and Lightroom were released within a few weeks of each other. While Lightroom works when run on a Windows Vista, there are a few hitches here and there, enough so that Adobe didn't list Vista support along with Windows XP for the initial 1.0 release. Don't get in a twist over this. Adobe wasn't the only major vendor that didn't immediately offer Vista support when Microsoft finally shipped it. Many Windows users now discovering that while Vista looks pretty, it generally slows down overall operation and they have returned to Windows XP (**Figure 1.12**).

FIG 1.12 Network Attached Storage devices like this one from HP are becoming essential to professional photographers.

Networking and Shared Resources

Lightroom can work over networks but it wasn't designed to do so. Oh great, what does that mean? It means that there are two issues when working on a network that wouldn't be there if Lightroom was designed over a network. The first is that Lightroom maintains its library of image thumbnails and other stuff on each local computer. For example, my Italy collection on the Network Attached Storage (NAS) drive is composed of 2900 images. I have three computers connected to that drive (a notebook, a desktop, and an iMac). To see the Italy collection on all three computers, it is necessary to import the photos onto each computer and maintain three separate and identical sets of the collection because Lightroom catalogs cannot be stored on a network drive. Maybe, they will include this in the 2.0 release.

The other sticky point is that Lightroom needs to constantly chatter back and forth with the hard drive(s) containing the photos. If the images are kept on a network drive, such as the increasingly popular NAS device, it adds several more network protocol layers that Lightroom must navigate to stay in touch with the images. Given that, it works well most of the time, which is until the NAS is reset, shutdown, or the network temporarily goes offline. The moment that happens and Lightroom loses touch with its little family of photos panic sets in and Lightroom declares all of the photos are missing and all folder names shown in Lightroom turn red – they're not going communist – that's Lightroom's visual way of saying there are missing photos in the folder or the entire folder is missing. Is it just me or does Lightroom sound like a drama queen? Instead of checking to see if the folders are present when the network connection is restored, Lightroom feels compelled to open every folder and sub-folder and verify whether each photo is where it belongs – a time-consuming process. It is my hope that Adobe will someday add a 'faith' option that assumes once the network connection is restored, the contents of the folders haven't changed or been abducted by aliens.

Other than this little quirk, Lightroom works well with NAS devices which in turn provide a great way to share files between Macs and PCs. After all those cool Apple commercials we now know that Macs and PCs get along well – or at least as well as can be expected.

One Program – Five Modules

Lightroom is composed of five modules: Library, Develop, Slideshow, Web, and Print.

- *Library*: Used to sort photos, add metadata, and do quick image corrections.
- *Develop*: From this module, you can perform a wide variety of image enhancements or pass the image in question to an external photo editor.
- *Slideshow*: Create slideshows to show off your work.
- *Print*: Just what the name implies. From here you print your photos on a printer.
- *Web*: Produce professional-looking Web galleries.

Unlike other programs that open additional applications to process images, with Lightroom you select the photo and then choose which module of the program to switch to – much faster.

Navigating and Managing Lightroom

Lightroom is easy to navigate once you know how. First, let's learn the names of some of the major parts of the Lightroom interface. **Figure 1.13** shows the major components of the user interface (UI). Egad! You have probably noticed there is hardly any room left to show the thumbnails of the images.

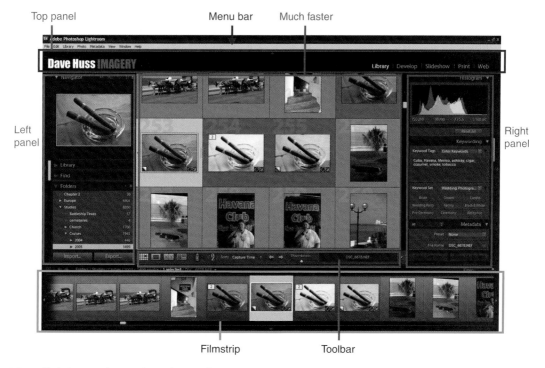

Top panel Menu bar Much faster

Left panel

Right panel

Filmstrip Toolbar

FIG 1.13 The Lightroom workspace with everything turned on.

Main Menu

The main menu commands are located in the Lightroom menu bar at the top
of the screen. If you are in absolute full-screen mode, the menu bar is hidden,
but can be revealed by changing the mode pressing the F key or moving the
mouse up to the top of the screen.

Top Panel

The top panel section in Lightroom contains the module picker, allowing
you to move between the different Lightroom modules with the click of a
mouse. The top-left section also contains the Identity Plate under which
you can see the progress indicator – when Lightroom is busy working on
something.

Grid View or Image Display

This is the part of the interface where you view, select, sort, and work with
the photos. How this area appears depends on the module you are in and
what mode you are in as well. For example, in the Library module Grid mode
(shown in **Figure 1.14**), the thumbnails are displayed like a traditional light

13

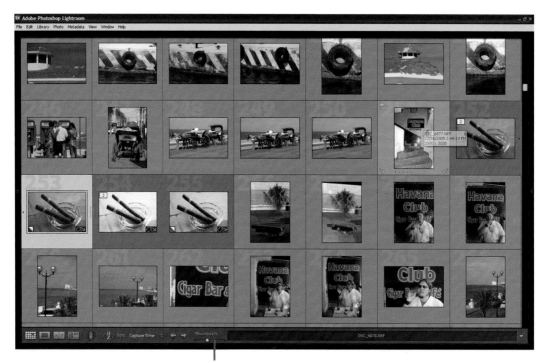

Controls thumbnail size

FIG 1.14 The Grid view makes photos appear to be on traditional light table.

table. The size of the thumbnails is controlled by the slider on the Toolbar. In the Library module Loupe mode or Develop module, you see individual images displayed in different zoom factors. In other modules Slideshow, Print, and Web, this area functions as previews of how images will appear when they are output from Lightroom.

Toolbar

The Toolbar (at the bottom of the screen) is toggled on and off by pressing the T key. It is common to all Lightroom modules. It contains different tool sets depending on the module currently selected.

Right Panel

In the right panel, you generally find the controls for adjusting an image, information about an image (metadata), or image layout settings. The Panel options can be expanded or collapsed by clicking the name of the panel bar – for example, Folders. Clicking a panel bar toggles it revealing the contents of that panel.

Left Panel

The left panel is where you manage your photos and control presets. This is especially true when you are in the Library module, the left panel is used to manage folders, collections, and keywords.

Filmstrip

The Filmstrip at the bottom of the screen contains thumbnails of all the images currently displayed in the Library. The Filmstrip thumbnails can be accessed in all of the modules. This is a handy way to access the images or even a group of images without having to switch back to the Library module.

The image shown is in the Library module in Grid mode. Each part of the Lightroom interface (panels, toolbars, etc.) can be individually opened and closed to allow more room to display the thumbnails, which quite frankly, could take a lot of time. Press Shift+Tab to show or hide all of the panels (Figure 1.14). Now you can see all of the thumbnails without all of the other panels cluttering up the screen.

Where is the …?

Lightroom panels are shy. They will hide from view if they get a chance. If a panel is hiding, move the mouse to the edge of the screen where the panel is and it will reappear. There is an icon that is on the screen edge side of the panel. Click on it and it rotates so that the flat side of the icon is against the panel; now when you move the mouse away, the panel remains open. The only hiccup to this arrangement is that sometimes when you are moving a scroll bar on the edge of the screen, it is interpreted by Lightroom as a request to open a panel.

There's a hiding panel option you'll want to know about. You already know that when you hide a panel, it will automatically pop back into view if you move your cursor over that edge of the screen. This feature is called Auto Hide, and while it is handy, at times is seen counter-productive with the panels popping open when it smells the mouse closing on the edge. Never fear, you can turn Auto Show/Hide off by right-clicking (Cmd-click Mac) on any one of those Show/Hide icons. This brings up a contextual menu where you can choose your panel options. Since the option names are less than clear, I thought a few words might clarify the operation. The options are as follows:

• *Auto Hide & Show*: Default setting – Panels jump out of the screen edge when they sense a mouse nearby.
• *Auto Hide*: The only way to open a hidden panel is to click on its Show/Hide arrow, but when your cursor moves away from that panel, it automatically hides.
• *Manual*: The name says it all. You can use the arrows to show and hide every time.

During beta testing, the other testers would be talking about one of the panes inside of the panels, but it wouldn't be visible on my screen. It took me some time to figure it out. If it seems that some panels are missing, right-click (Cmd-click Mac) the panel and a list of the available panel options appears like the one shown in **Figure 1.15**.

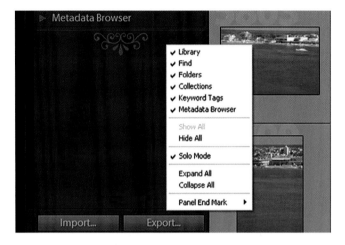

FIG 1.15 If part of your panel is missing it is because it wasn't selected on the list.

The Power of Keyboard Shortcuts

Each module (Library, Develop, Slideshow, Print, and Web) has a different set of panels and features. The key to smoothly navigating Lightroom is to learn some basic keyboard shortcuts. We have already seen what Shift+Tab can do. The next keyboard shortcut is made for all of us who can't remember shortcuts. Pressing Ctrl+/ (Cmd+/Mac) overlays the shortcuts for the module you are in. In **Figure 1.16**, I was in the Library with Professor Plum and the candlestick (sorry), so it showed most (not all) of the shortcuts for that module. You have to admit this is pretty slick.

Here are some other useful shortcuts you should know.

- F – Cycles through all three screen modes (**Figures 17a–c**); works in all modules. So when you can't find a menu, press the F key.
- L – Cycles through the Lights Out modes (**Figures 18a–c**); works in all modules – It not only controls the lighting in Lightroom but also other applications running at the same time. This one is good when you want to show your photos to someone without any other applications distracting the viewer.
- J – Cycles through the three different Grid views (**Figures 19a–c**); only works in Library, Grid mode.
- G – Switches to Grid mode in Library module. A fast way to get to the Grid from any module and mode in Lightroom.
- T – Opens the Toolbar in any module.

Now that you know some of the basics, in the next chapter, we will learn how to import photos.

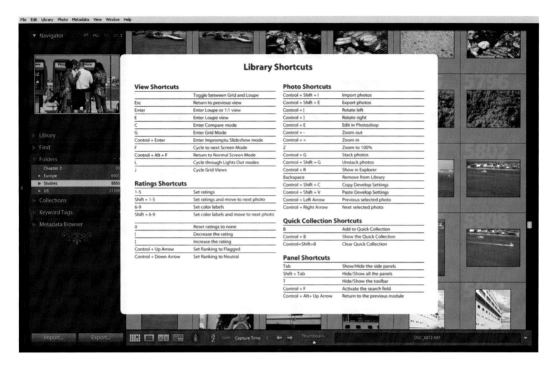

FIG 1.16 Module specific lists of keyboard shortcuts saves you from the need to memorize them.

FIG 1.17 Pressing the F key lets you quickly cycle through the three screen modes.

FIG 1.17 (Continued)

FIG 1.18 The Lights Out mode (L) is a quick way to dim distracting elements on the screen.

FIG 1.18 (Continued)

FIG 1.19 Use the J key to toggle through the different Grid views.

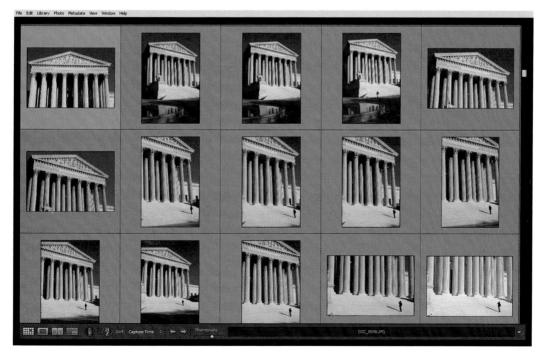

FIG 1.19 (Continued)

Getting Photos into Lightroom

Before you can do anything with Lightroom you have to get the photos into your computer. Lightroom can bring photos in from cameras (card readers or direct connection) or it can import images that are already on the computer.

> **TIP**
> Regardless of how you import your images, taking some extra time to ensure that your import is set up correctly before you begin will save you a lot of time later.

From the Camera to Lightroom

If you are using Lightroom you don't need me to tell you how to physically connect your equipment to move the images from the memory card to the computer. Having said that, I will make a few suggestions to ensure the transfer happens as quickly as possible. First and foremost, use a card reader to transfer the photos instead of a USB connection directly to the camera

FIG 2.1 High-speed Card readers
download faster than direct
connections to cameras.

(Figure 2.1). The card reader is faster because the computer controls the transfer whereas when a camera is attached to the computer, the processor in the camera controls the transfer and that processor was not designed for speed. The exception to this rule is a tethered camera.

Setting Up Import Settings

The Import settings for Lightroom are on the Import tab of General Preferences [Ctrl+,] (Figure 2.2). From this tab you can control how Lightroom treats Raw+JPEG photos, digital negative (DNG) images, and those lovely folder names the camera generates. At this point we are interested in the setting that determines if the Import dialog box opens when a camera or card reader is connected to the computer. This setting only controls Lightroom's Import dialog box, it does not affect how the operating system (OS) and other applications respond – and they will respond.

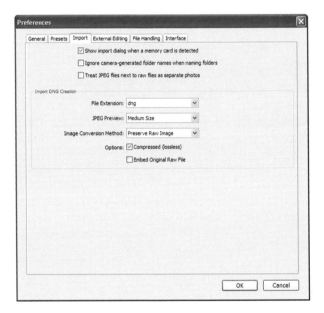

FIG 2.2 The Import tab of Preferences controls how Lightroom reacts to USB devices.

Once the card reader (or camera) is plugged into the USB port you will be faced with an assortment of choices. Plugging in a camera or card reader can be equivalent to asking a number of toddlers 'who wants ice cream?' Depending on what applications you have installed, numerous dialog boxes may pop up on your screen offering to download the photos for you. For Windows users, one will be the Action dialog box like the one shown in Figure 2.3 popping up asking what you want to do with the images in the memory card. When there are several Adobe applications installed that have downloaders, the Adobe Photo Downloader (Figure 2.4) appears and you need to select the one to use.

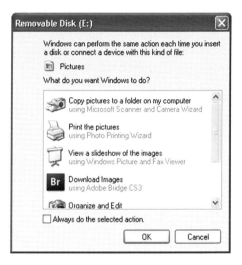

FIG 2.3 Windows Action dialog – one of too many programs that offer to help you download your photos.

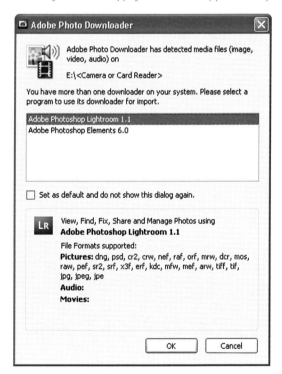

FIG 2.4 Adobe Photo Downloader offers to begin Import into installed Adobe applications.

At this point you have two choices available to you: use your computer's OS to copy the image files to the computer. It is fast and simple but after transferring them onto the hard drive, you are still going to have to import them into Lightroom. Use Lightroom to import the images – this

takes a little longer than doing a straight copy to the hard drive but overall it takes less time since you are combining the copying and importing into one step. Selecting Lightroom in the Adobe Photo Downloader opens another dialog box when a camera or card reader is connected to the computer.

Stop Before You Do Anything Else

Measure twice, cut once is an old saying but it is really apropos for Lightroom. Before you begin importing, stop and decide how you are going to proceed before doing anything else. If you don't you heed this advice you will end up with several thousand images imported before discovering you have added the wrong keywords, put them in the wrong folder, or worse applied the last settings to the current import.

The last time I messed up (one of many), I ended up with over 1000 images from Barcelona, Spain with each image file named *New Orleans* before I caught the mistake.

So, before you begin using Import to either catalog all of your existing images or importing images from your latest shoot, pour yourself a drink, sit down with this chapter and a pad of paper and decide *beforehand* what you are going to do. Here is a checklist of points to consider:

- *Renaming Files*: Do you want to keep the original file name produced by the camera or change it to a custom name? There is a natural hesitation to change the name since it somehow feels like you are altering the original – even though you are not. Lightroom offers several recommendations for file-naming formats in the form of presets and by using the File Template Editor you can use any combination of elements to create a custom file name. Here are some samples of renamed files:
 - **Italy Rome 2006 0001** (custom text and sequence number).
 - **Wedding Smith 04292006 001** (custom text, date, and sequence number).
 - **Muleshoe HS Class S2008 05152007 01 01** (custom text, date, image number, sequence number).

 I suggest avoiding insanely long and complicated file names. There are several reasons the best being simple is better; but also because long file names are difficult to read when viewing a folder since the ends of the name are often truncated as shown in Figure 2.5.

- *Existing folder management*: If you have a current system of folders that you are comfortable with, I suggest continuing using that organization. In theory, using Lightroom's image management capabilities, you could put all of your images into a single folder. Not a good idea. First, while Lightroom is an excellent workflow tool the current version won't win any prizes for

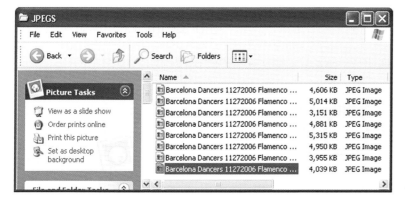

FIG 2.5 Really long file names can look identical if the computer truncates the view.

image management. Second, most computer OSs operate best when data is organized into a system of folders and subfolders. Third, continuing to use your current system allows you to find files without using Lightroom. For example, let's say you wanted to copy all of your photographs of the **Lulling, Texas 2006 Watermelon Seed Spitting Contest** (yeah, there really is one – you gotta love Texas). It is a simple thing to drag the folder to a CD icon to burn a copy of the folder and you don't even need to wake Lightroom up to do it.

• *Starting from scratch*: If you don't have an existing system of folders or you're not happy with your current system this would be a good time to spin up a new one. Here are some suggestions:
 – *Reduce number of top-level folders*: The pane that allows you to view the folders isn't terribly large and so the fewer numbers of top-level folders the less space is used up when the folders are closed.
 – *Decide on your organization before your first keystroke*: It takes less time to plan the organization and make sure it works on paper than it does to undo it halfway through the importing or worse, working with an organization that doesn't fit your workflow.
 – *Setup your file organization using your OS*: Unless you are uncomfortable using the OS on your system, setting up a system of file folders before you begin importing photos is much simpler and faster than using Lightroom to do it. Once you have the folders in place you can then import the images using Lightroom into their new folders. An exception to this suggestion is if you are renaming the files, then you should use Lightroom to do the entire job.

TIP
Just because there is an Import feature doesn't mean you have to use it to do everything. Less is more.

Importing Photos

This section looks as much fun as reading a phone book but it is less a how-to and more an accumulation of experience from importing more than 60,000 images (many images were imported multiple times).

Like all applications these days there are multiple ways to do everything. In Lightroom you begin the import process by either plugging in a camera/card reader, selecting Import Photos from Disk in the File menu, or clicking the Import button in the lower-left corner of the Library module. There are other ways to do it, but that's enough for now, let's import some photos.

1. From the top – **File Handling**: Pick whether you want to copy or move the images or reference them where they are at. When the Import process begins, the Import Dialog box opens and from here we need to change the settings that define how the import will occur. First, you have the opportunity to select the location from which the photos are to be imported. When importing images your choices (Figure 2.6) are to copy or move the images from their current location (like a memory card) to a folder on your hard drive or you can catalog images right where they are at – handy for files you already have on your hard drive. When reading images from a camera or card reader, Lightroom will only allow you to copy the images to a new location – which is only good sense. Lastly you can even convert the images to Adobe DNG before copying them to a new location.

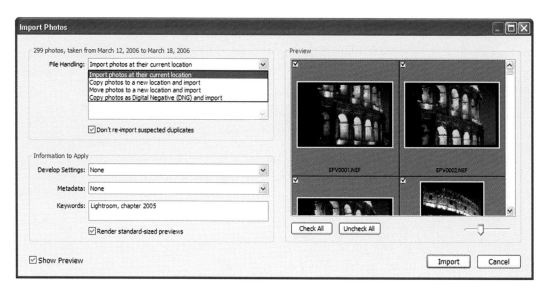

FIG 2.6 Select how you want the images handed when they are imported.

If you already use the DNG format, it is best to select this choice since Lightroom will convert your images to DNG as part of the import process. There are several options for how Lightroom processes the photos to DNG

which are controlled in the Import tab of the Lightroom Preferences. If you don't use DNG already, spend some time and see if using DNG format is a good solution for you before you begin changing all of your images to it.

2. If your Import Dialog box doesn't display the preview thumbnails like the one shown in Figure 2.6, ensure **Show Preview** (lower-left corner) is checked. By default, all of the preview images are selected. If there are some images that you don't want to import, simply uncheck the thumbnails. The size of the preview thumbnails is controlled by the unmarked slider in the lower-right corner. Preview selection is a really handy feature when importing from a memory card containing images from multiple shoots as it allows you to import only the images that you want.

3. Next, check **Copy to** and make sure the files are going to the correct folder. The example in Figure 2.7 shows the name of the destination to the left of the Choose button. If the path displayed isn't correct, click the **Choose** button and change the destination. Also notice that the ultimate destination in Figure 2.7 is a folder named ALBM0002 because it was organized **By original folders** and ALBM0002 is the name of the folder being imported.

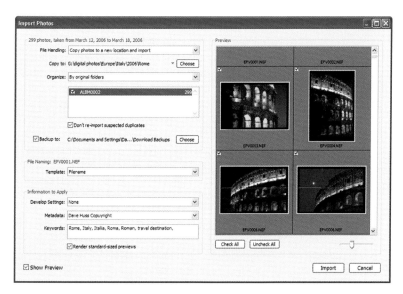

FIG 2.7 Choose the destination for your images.

4. *Organize* appears to have a lot of choices but there are actually only three. The choices are to put all of the photos into the same folder, put them into folders with the same name and structure as the source, and the rest of the choices on that long list are different date formats for a folder name (Figure 2.8). If you select **Into One Folder**, another choice appears (**Put in subfolder**) which gives you an option to tuck all of the images into a named subfolder of the folder selected with the Choose button. If you select this choice, don't forget to enter a name or Lightroom will name it *Untitled Import*.

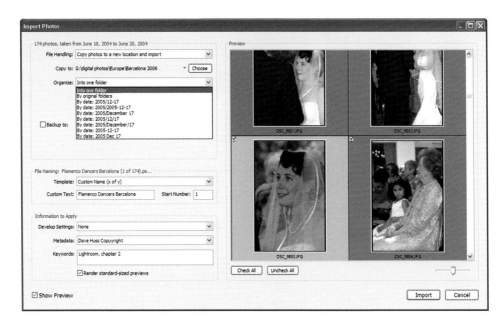

FIG 2.8 Using the Into one Folder during Import simplifies collections.

5. There are two more options in this section. **Don't re-import suspected duplicates**, if selected, compares files being imported with those already in the catalog. Files with matching names + EXIF capture dates + file length (size) are considered duplicates and not re-imported (if the option is checked). In other words, only if the file is an unaltered duplicate of one that is already cataloged, it won't be imported.

 The other option (**Backup to**) produces a duplicate copy of all of the imported files at a different location on a hard drive. It is a nice safety net that I like to use during location shooting. Lightroom does not burn a CD/DVD. I recommend putting the backup Lightroom creates on a separate external hard drive. Putting the photos and the backup on the same hard drive isn't much protection if the hard drive fails or someone steals your notebook.

6. **File naming**: This was discussed earlier in the chapter. Once again, the list (Figure 2.9) appears long but essentially there are only three choices. File name (original name remains unchanged), file name is replaced with one of the many templates, and Edit. Edit opens the **Filename Template Editor** (Figure 2.10a). From here you can define a combination of elements and save them. Using the Editor is pretty much self-evident except for the custom text; you can include custom text in the template, but the template doesn't actually contain the custom text; that must be entered in the Custom Text field back in the Import dialog box.

7. **Develop Settings** gives you the option of applying any of the settings from the Develop module. Be cautious while using this feature. It is rare that any one setting is appropriate for all of the imported images. Now

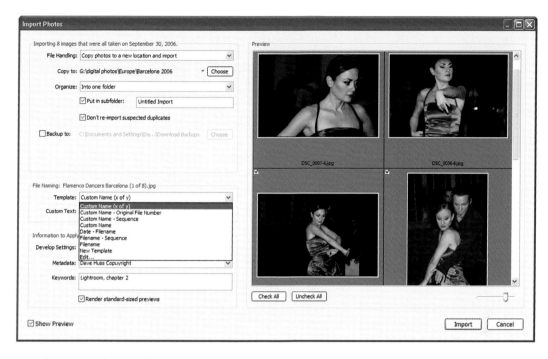

FIG 2.9 File renaming replaces cryptic file names with topical ones.

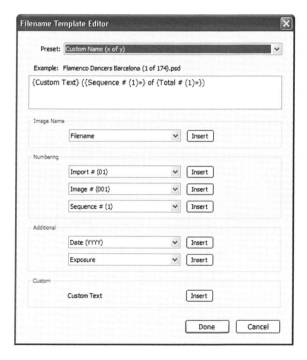

FIG 2.10a Create your own custom filename templates.

that I said that, like all of the settings in Lightroom, the settings applied during Import can be removed at anytime.

8. **Metadata**: This is most often used for adding your studio and copyright information, a great way to add your copyright information to photos. Before putting copyright information on a photo you should be aware that if you give the image with your copyright to a friend to have prints made, the photo developer will not make copies without written authorization from you.

 Selecting **Edit Presets**… opens the **Edit Metadata Presets** dialog box (Figure 2.10b). From here you can add almost anything to the metadata fields and it will be added to all of the imported photos. Using this isn't rocket science but you should be aware that after you create a new metadata preset you can go back and edit it at a later date but you cannot change the name you give the preset (notice the spelling of copyright in the preset name in Figure 2.9). Also, you cannot delete metadata presets. There is actually a way to delete custom presets but it is complicated and secret so if I were to tell you I would have to kill you (kidding).

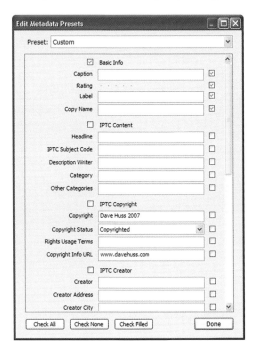

FIG 2.10b This dialog box defines the Metadata presets.

9. **Keywords**: If you shoot stock photography this feature is essential. If you are entering a keyword that you used before, as you type in the keywords (separated by commas), Lightroom autocompletes the keyword. This sounds great, but on occasion it can be intrusive as you are typing in a word while Lightroom keeps trying to help. For example, I wanted to add

the keyword *Roma* (Italian for Rome) and Lightroom kept trying to change it to *romance*.

If you are running Lightroom on a Mac, you can run a spell check of the keyword field as spell checking it is part of the OS but not so on a Windows platform. If the keyword you are using is part of a hierarchical keyword, it will appear with the greater than sign (>). For example, if keyword *canal* is under *water* (no pun intended) in the existing keyword listing, it will appear as canal > water when Lightroom autocompletes it.

TIP
A quick way to check your spelling with Windows is to open a Notepad, copy and paste the contents of the keyword field into a document and click F7 to evoke the spell checker. Make any corrections and then copy and paste the corrected keywords back into keyword field.

– **Render Standard-sized Previews**: The last option is an important setting. Rendering standard-sized previews while importing them is a real timesaver. Early in beta testing it was a common practice to turn this feature off because it really increased the amount of time it took to import images. Now, Lightroom renders these standard-sized previews really fast.

You have the option to render the previews at a later time, but be aware it takes Lightroom far less time to render thumbnails during Import than when done after Import. I'm not sure why this is, but it is a fact that if you can, you should render thumbnails when importing images.

10. Finally, click the **Import** button and the process begins. At first it appears that nothing is happening. Watch the upper-left corner and you will see a very small progress bar under the Identity Plate indicating that the import is occurring (Figure 2.11). After a number of images have been imported their preview thumbnails will begin appearing several at a time. If you want to see what percentage has been completed, minimize the Lightroom window (which will speed things up slightly) and the percentage completed will appear on the Lightroom tab in the status bar (Windows). When the progress bar disappears, the import has completed.

FIG 2.11 Progress indicator displays what Lightroom is doing.

TIP
Before you import images in Lightroom check ALL of your settings. Lightroom uses the last Import settings. If you do not change them your last settings will be applied to the current imports. Many settings applied during import are difficult and time consuming to correct.

Importing Images via Drag and Drop

Another way to import images into Lightroom is to simply drag and drop files from a camera card or folder into the Library module. It does not matter which folder (if any) is selected, since this method of import also opens the Import Photos dialog. From this point on, the Import operation continues as previously described.

> **NOTE**
> If you scan file with any of the excellent Nikon Coolscan film scanners one of the options you have is to save the files as NEF files which is the extension used for Nikon Raw file. Don't do it. A Nikon Coolscan NEF is not a raw file. It is a proprietary linearized format that only works within Nikon software. Save your scans as TIFFs unless you plan to exclusively use Nikon software to process them.

Lightroom Speed Bumps

Isn't it great when everything works the way it is supposed to? Believe it or not, sometimes Lightroom won't import all or some of your images. The message that explains why some images were not imported on occasion isn't crystal clear so I thought I would provide a visual listing of some of my favorite speed bumps.

Import Results

Lightroom is able to import all the supported raw file formats. It can also import RGB, L*a*b, and grayscale images saved using the TIFF, JPEG, or PSD file formats. Non-raw images supported include both 16 bits or 8 bits per channel. At times you may discover that Lightroom will not import a Photoshop (PSD) file. No mystery here, for a PSD file to be imported into Lightroom, the file must have been saved with the Maximum Compatibility option switched on. This restriction only applies to images saved with later versions of Photoshop.

After clicking the Import button the following dialog box (Figure 2.12) may appear. This doesn't mean that there are not any photos. This example occurred when I attempted to catalog a number of photos that were already on the hard drive where the rest of the photos are maintained and were already in the catalog.

FIG 2.12 The wording of this box doesn't mean there are no photos.

Here is another example (Figure 2.13). This example is clear. The selected images I wanted to import were already in the catalog but they were not located in the same folder as cataloged image.

FIG 2.13 This shows that four of the images have already been cataloged.

If you click the **Show in Library** button, the images that already existed in the Lightroom catalog I am using appear (Figure 2.14). The Save As button allows you to save a list of the files that were not loaded as shown in Figure 2.15. This list can be helpful when you are trying to determine which files are duplicated.

FIG 2.14 Visual display of images that were already imported into Lightroom.

FIG 2.15 Lightroom makes a printable list of images that were not imported.

Sorting the Good, from the Bad, and the Ugly

Once you have your photos imported into Lightroom, your next step is sort through them and separate the keepers from the creepers (throwaways). In Lightroom this is a relatively simple process from the Library module. Here is one way to do it.

1. Go to the Grid mode (G) and double-click the thumbnail of the first of the images that you want to sort. This action opens the selected image in Loupe mode (Figure 2.16). Open the Toolbar (T). Clicking the Select Toolbar Content icon in the lower-right corner opens the list of Toolbar options that can be displayed. Pick the ones you want – I picked them all for this example.

FIG 2.16 Selecting the options to be viewed in the Toolbar.

2. If the image needs to be rotated (like the one shown in Figure 2.16), click one of the two rotation arrows in the center of the Toolbar. In the example shown, I have hidden the Filmstrip to allow more room for the portrait (tall) orientation to be viewed.

NOTE
Some photos are rotated to the correct orientation automatically and some are not. Why? Autorotation only happens if your digital camera includes the image orientation of the camera at exposure time in the image file.

3. If the photo is junk, pressing the Del (Delete) key presents you with the choice of removing the image from the Lightroom catalog or deleting it from the hard drive (Figure 2.17).

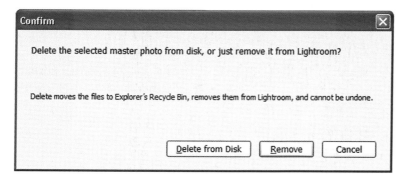

FIG 2.17 Choose whether to remove the image from Lightroom or the hard drive.

4. For critical image examination, you need to use the Z key to Zoom in and out. The Zoom key jumps between Zoom settings shown in the Navigator panel on the left. Clicking the Change Zoom icon (Figure 2.18) allows you to select one vof several choices to be used for the last Zoom ratio setting. To change the zoom settings that the Z key jumps to, just press the key and then click the zoom ratio in the Navigator panel.

TIP
When the Left panel is temporarily opened by moving the mouse against the left side of the screen the panel overlaps the current image, covering up part of it. If the panel is opened by clicking its screen side icon so that it stays open, Lightroom resizes the image to fit in the remaining space.

5. To move to the next image, you can use your arrow keys on the keyboard or you can use the navigation arrows in the Tool bar.

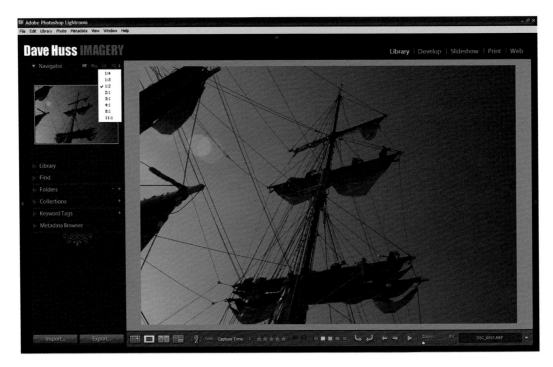

FIG 2.18 Select the optimum zoom settings for your workflow.

Working Message Appears on an Image

Why does the word 'working' sometimes appear on a photo? When you zoom in on a photo Lightroom has to render a view of the requested size. When you are working with large images it can take a few moments – or longer – for Lightroom to render the image. So while you are waiting the word 'working' is displayed on your image. Please be aware that until 'working' disappears from the image, you cannot evaluate the image you are seeing. By that I mean that the sharpest, clearest image in the world may look muddy or out of focuses while waiting for the image to be rendered; so be patient and know that during beta testing the rendering took about 10 times longer – or at least it seemed to. See Figure 2.19a and b for a comparison of how the image appears while it is being rendered and completed rendering.

Comparing and Rating Your Photos

Lightroom has included several tools to allow you to compare photos and a huge number of ways to rate these photos. We'll start with comparing images. Most of us when we shoot a photo take several shots of the same subject. Trying to compare photos by jumping back and forth between them on a

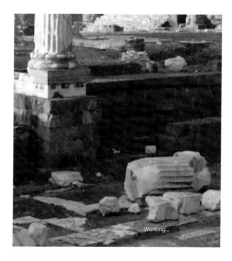

FIG 2.19a Image (close-up detail) appears soft and out of focus as Lightroom renders the thumbnail.

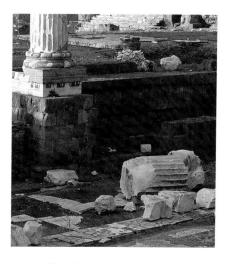

FIG 2.19b When finished rendering the photo shows that it is sharp and in focus.

computer screen doesn't work, so Lightroom allows you to view them all together. Here are some ways to go about it:

1. Select two images that you want to compare. In Figure 2.20 I have Ctrl-selected two images in the Filmstrip.

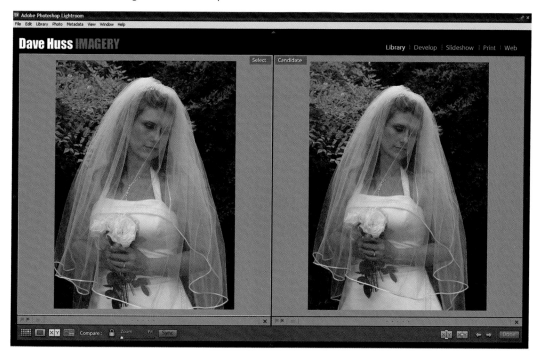

FIG 2.20 Comparing two nearly identical images.

2. Press the C key to open the two images in Compare. They will appear with the labels Select and Candidate. Both of these images are synchronized so that zooming in on one causes the other to zoom in at the same amount. This provides a quick way to compare the two images (although it was designed to compare before and after results). But what if you have more than two shots you need to sort out? No problem.

3. To view multiple photos for sorting, use the Survey View (N). In Figure 2.21, I selected five photos of a beautiful bride (my daughter) and pressed the N key. Now I am presented with all five on the same screen. This is a good time to use the Lights Out mode (L key) to make the background go solid black.

4. As the cursor is passed over a photo a small black and white 'x' appears in the corner. Clicking on the 'x' removes the photo from the consideration but not from Lightroom. When the photo is removed, all of the other photos are resized and redisplayed as shown in Figure 2.22. Once you have the image that you want (Figure 2.23) you can mark it as a keeper – which is our next topic.

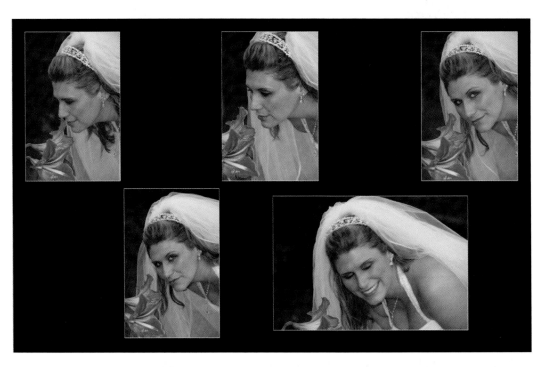

FIG 2.21 Survey view allows you to view all of your choices.

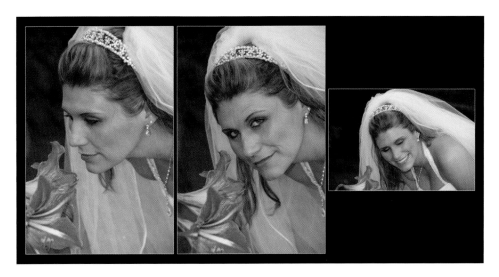

FIG 2.22 As photos are removed the remaining images are resized and rearranged.

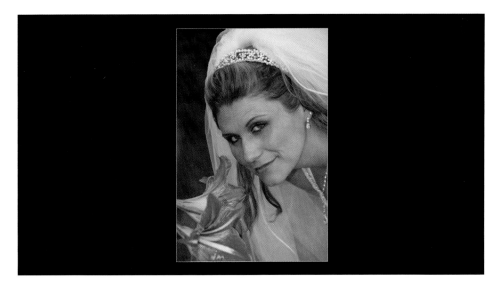

FIG 2.23 From five potential photos to one in a few seconds.

Rating Your Photos – So Many Ways

Lightroom developers went a little overboard when they came up with the rating systems (plural) that they designed into Lightroom. Here is a short list of the ways that you can rate photos:

- Stars – Just like the movies your photos can have zero through five stars.
- Flags – A more simplistic approach in which choices are Flagged as Picked, Flagged as Rejected, and not flagged at all.

- Color Labels – If you are not into stars or flags, then you can use color labels which can be used as an excellent process control tool.

Here are some thoughts on the various systems beginning with Stars. While stars are great for rating movies, it has limited usefulness for most professional work because it is so subjective. For example, the best shot on an otherwise poor shoot – should it be a five star (relative) or is it a one star when compared to other shots within your collection? I know that out in the expanse of Lightroom users there are many of you that have not only perfected the use of stars for rating photos, but are even now considering if you can make a Special Interest Group (SIG) just for star users. If you do use it successfully, I say good for you. It just didn't fit within the systems of most photographers that I worked with.

Working with the Stars

Stars are pretty simple really and while there are several ways to do it, the most simple method when the image is selected is to press the number key 0–5 to match the star rating. When you do, a text message appears on your image for a moment and the number of stars you selected appears in the Toolbar as shown in Figure 2.24. To change the number of stars for a photo just select the image and pick a different number (0–5). Pressing the zero key will remove all of the star ratings from a photo until it checks itself into rehab. To apply star power to multiple images, go to the Grid mode, or from the Filmstrip, select the

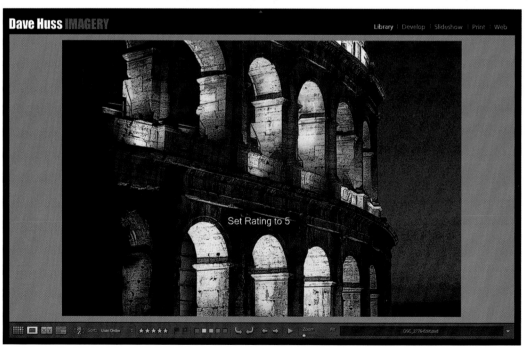

FIG 2.24 Setting a star rating in Loupe mode.

images you want to bless with stars and press the desired number. Figure 2.25 shows several images with a three-star rating in Grid mode.

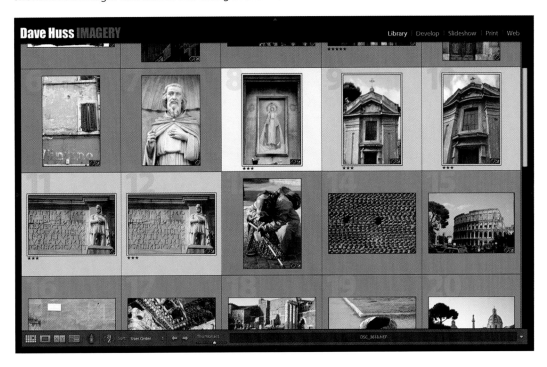

FIG 2.25 Setting star ratings on multiple images in Grid mode.

> **TIP**
> If you can't see the stars in Grid mode, press the J key to change the view until the stars appear.

Flags – Simple and Effective

This is the tool of choice for sorting images. When the shoot is done at the end of the day you just want to find the best shoots, delete the flops. Everything else is details. After you have completed the first pass to remove all of the horrific failures, it is time to pick the ones that you want the client to see. Flags are perfect for this. As each photo appears in Loupe (E) view or in Grid (G) mode, press the following keys to sort the photos:

- P key to add a Pick flag.
- U key to remove a flag.
- X key to add a Reject flag.

The flag status appears in either the Toolbar or the Grid View (Figure 2.26a–c). If you have already sorted your images and removed the bad ones prior to adding flags, you won't need to use the Reject flag (X). Just a reminder for

those that use the Reject flag, it is the X key, not the R key (which oddly enough switches you to the Develop module and enables the Crop tool). X = Reject, R = Crop. Seems backwards to me but I and others have accidentally used R for Reject enough times that I thought a small reminder would be instructive.

FIG 2.26a Flagged as Pick.

FIG 2.26b Flagged as Rejected.

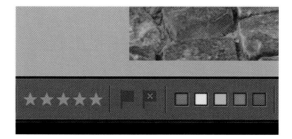

FIG 2.26c No flag.

Working with Color Labels

Color Labels are different from the previous two methods because each of the five colors can be defined by you and given a custom name. Most of the people that I interviewed didn't use Color Labels to rank photos but instead used them to manage their process. To define the meaning of each color, open Metadata, Color Label Set, Edit… (Figure 2.27). The Color Label Set that is shown in Figure 2.28 are the labels I use for location shooting.

FIG 2.27 Selecting the Color Label set.

Edit Color Label Set

Preset: Location shooting

Unprocessed shots	6
Processed	7
Sent to iStockphoto.com	8
Needs Model Release	9
Resubmit	

If you wish to maintain compatibility with labels in Adobe Bridge, use the same names in both applications.

Change Cancel

FIG 2.28 Making a custom Color Label set.

It is instructive to show some of the uses that the color labels can be used for. When on location my habit is to return to my motel room, sort out all of the bad images and then from the grid mode select all of the photos I took in that shoot using Ctrl (Command) + A before applying the red color label since at this point they are all unprocessed. So, what is the key for Red? Look again at Figure 2.28.

FIG 2.29 The menu-based way to select the last color label.

See the numbers to the right of the descriptions. In this case, pressing the number 6 assigns the red color label. So, what about the last color? It doesn't have a number. There isn't a keyboard shortcut, so you must choose Photo, Set Color Label, name of color label set, and then click on the last item as shown in Figure 2.29. Because it is buried deep in the menus, using it is about as smooth as sandpaper; so make sure when you are setting up the Color Labels that either don't define the last color or use it for the least frequently used definition.

Back to using the color labels. After I have worked on the image I change its color label to yellow. At any time, I can filter the shoot by color label and see just how many more images I have yet to process – which can be depressing if it has been a long day.

Filtering the Results

Now that you have all of the stars, flags, and color labels in place, it is time to make some use of them. The quickest way, of many, to filter the current folder by stars, flags, and/or color labels is to open the Filmstrip. Look at the bottom right and see if all of the icons appear as shown in Figure 2.30. If they don't click on the word 'Filters,' then they will appear.

In Figure 2.31, I have clicked on the yellow square (processed images) and only the processed images now appear. What if I wanted to see all of the processed

FIG 2.30 No color label selected, all images in folder are available.

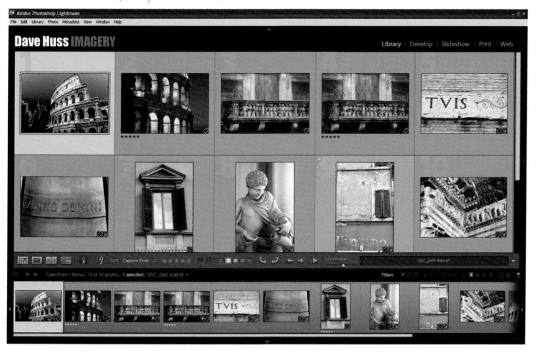

FIG 2.31 Yellow color label filter selected, only processed images appear.

images that have a five-star rating? All I need to do is to click on the last star to the right in the same bar and now only five-star processed images appear (Figure 2.32).

FIG 2.32 Yellow and five-star selected, only four images have both.

To turn off an individual filter, just click on it again. To turn off all of the filters, use Ctrl+L.

Finding Photos Without Color Labels

There will be times that you are not looking for color label, but rather looking for a photo that somehow missed getting a color label. Here is how to do it.

1. Go to Grid mode (G).
2. Show all your images by selecting the folder in the Folder pane that contains the photos in question. Select the suspected missing color label in the Toolbar. All images with that color label will appear. Use Ctrl+A to select all of the photos. Turn off the color label and the other images will appear.
3. Select Edit, Invert selection and any images missing the color label will be selected.

Viewing the Results

You just spent the past few hours processing several hundred images and it would be nice to see the results of your efforts without creating an actual slideshow. This is why Adobe included Impromptu Slideshow. Located in the Toolbar next to the Thumbnail slider is an icon that looks like a play button (Figure 2.33). Here is how to use it.

FIG 2.33 The Impromptu slideshow button launches a slideshow of the currently selected images.

1. Filter your images so you can see only the keepers (or you can look at your worst – it's your choice).
2. Click on the Impromptu Slideshow button once and wait a moment. It takes Lightroom a little time to assemble the show. The larger the size and number of images, the longer it takes.
3. Enjoy the show. To stop the show at any time, press the ESC button.

Organizing Your Photos

Now that the photos are safely tucked into Lightroom, our goal is to find the best way for you to organize these visual jewels so that you can find them at a later date. The effort necessary to organize photos has increased with the advent of digital cameras. There was a natural barrier when we shot images with film. The cost of the film and developing had a dampening affect on the number of photos that we shot. When digital cameras first came along, the high cost of memory cards also provided lesser restriction on the number of images that we took. Today with high-capacity memory cards costing very little, consumer digital cameras with 5–8 megapixel sensors becoming commonplace, and hard drives offering almost limitless capacity it isn't surprising the photo collections have become increasingly hard to manage.

To be perfectly honest, Adobe Photoshop Lightroom isn't the best Digital Asset Management (DAM) tool available today. While it is better than Adobe Bridge, the Photo Organizer in Photoshop Elements can either match it or out perform it. Having said that, Lightroom's DAM capabilities are strong enough that it can do just about anything that the day-to-day workflow requires.

Lightroom Image Management Concepts

This section explains the major concepts of the image management features of Lightroom. The first topic is folders.

In Chapter 2, we learned that images could be imported into folders on a hard drive. The folders serve as a rudimentary way to divide a large collection up into manageable chunks. For example, Figure 3.1 shows the Folder Pane of

FIG 3.1 Folder view with all folders collapsed.

a large image library. All of the folders are collapsed. It appears to be rather small until the folders are expanded (Figure 3.2).

Folders provide a way to physically organize the image files on a hard drive but even using multiple folders and sub-folders, it is impossible to locate specific images in a large collection.

Stacking Photos

While folders help organize images on the hard drive, when faced with a collection of 20, 30, even 65,000 images, the display of the images becomes visually cluttered. One of the features that are specifically designed to reduce this clutter is called Stacks. The best way to explain Stacks is to show them in action. Figure 3.3 shows a typical collection of wedding photos.

FIG 3.2 Folder view with all other panes closed and folders expanded.

FIG 3.3 Multiple similar poses clutter up the screen.

Each pose has been shot multiple times at different settings to ensure that we have a good shot. While it is possible to pick the keepers and remove the rest, most of us want to keep all of the images (except the terrible ones) for safekeeping. So, when the Grid is viewed we are faced with multiple images of each shot cluttering up the view area.

Stacks let us stack all of the identical or similar poses one on top of another. Figure 3.3 showed thumbnails for 10 images. When the similar images are stacked as shown in Figure 3.4, the same area now contains 33 images. The only indication that they are stacked is the tiny icon in the upper-left corner with a number indicating how many images are in the stack.

FIG 3.4 Stacking hides multiple similar images to allow more photos to be seen on the display.

Here is how to stack photos into a group:

1. Open Grid mode in the Library module (G).
2. Select the photo that you want to be on top of the stack.
3. Using the Shift or Ctrl key select the other photos to be included in the stack.
4. Press Ctrl+G and all of the images except the top one will disappear from view and a tiny icon will appear in the upper-left corner indicating how many images are in the stack.

Stack stuff you should know

Working with stacked images is simple if you know a few shortcuts. First, to view the contents of the stack, select the top image and press the S key. All of the stacked images will appear on the grid. These images are still part of the stack group as indicated by the tiny *x* of *y* icon in the upper-left corner as your mouse moves over the thumbnail, as shown in Figure 3.5. Pressing the S key again returns them back into the normal stack view (hidden).

FIG 3.5 Use the S key to quickly unstack photos.

When you are in Loupe mode (E) you can only view the top image in a stack so if you want to view the images in a stack using the Loupe, you must first collapse the stack (S) before pressing the E key to enter Loupe mode. If you add a stacked image to either a Quick Collection (QC) or a Collection only the top image joins either collection.

There are several options that you can use to manage stacks which appear when you open Photo, Stacking as shown in Figure 3.6. OK, that's enough stack stuff. Let's look at Collections.

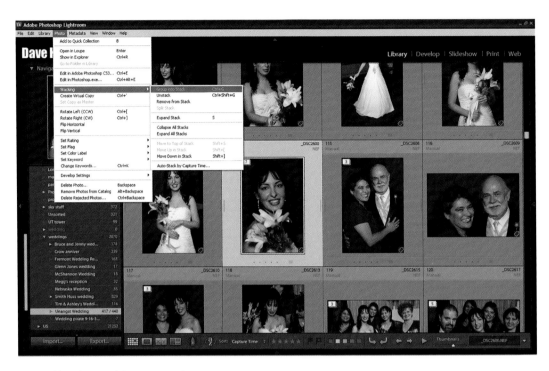

FIG 3.6 Additional commands for managing stacks.

Collections and Quick Collections

When you select a Folder in the Folder pane, all of the images in that folder appear in the Grid view. Lightroom lets you make a collection containing photos spanning across the entire Lightroom catalog. It may help to think of collections like scrapbooks. For example, if you were going to assemble a scrapbook of a local baseball team the first problem is that photos related to the baseball team are located in several different folders. Moving the photos from their current folders isn't an option because they are logically organized where they are; but you can make a Collection that includes all of the desired photos regardless of where they are physically located. What's nice is that these are copies of your Picks, so you're not wasting hard drive space by adding duplicate photos to make collections. In fact, add as many collections as you'd like, because they take up virtually no space.

Do not confuse catalogs and collections. Your catalog stores photos and their settings in a single place, allowing you to transfer your photos and settings to a different computer. A collection is a set of grouped photos within a catalog.

When you create a collection, Lightroom immediately opens the new collection, and now you can do things you couldn't do with a folder, like rearrange or delete photos without disturbing the original photos. Plus, you can add photos to your collection any time, from any folder, by just dragging a

photo from the grid (or filmstrip) and dropping it onto your collection and the same photo can be used in as many collections as you'd like. On top of that, collections can be nested meaning I can have a collection named Italy with sub-collections named Rome, Venice, and Florence. It provides a way to break up a large collection into manageable parts.

Creating a collection

Making a collection is fast and simple. Here is how to make a collection.

1. Select photos that you want to be included in the collection.
2. In the left panel, open the Collections pane, and click on the + symbol. This action opens the Create Collection dialog box (Figure 3.7).

FIG 3.7 Create Collection dialog box has changed in 1.1.

3. By checking Include Selected Photos, all of the selected photos will be added to the new collection. The example shown in Figure 3.7 was created as a child of Roma. This option appears if you currently have a collection selected when starting Create Collection.
4. The Make new virtual copies option is new to the 1.1 release. It means that virtual copies of the selected images will be created.

Working with collections

Once you have created a collection, you can add new photos from the Library module by selecting a collection in the Collections panel. From the Grid view, select photos and then drag them to the desired collection. The moved photos appear in the collection but physically remain in their original location. Removing a photo is also simple, select the image and press the Del key. Unlike removing photos from Lightroom, there isn't another dialog box that opens. When you press the Del key, ZAP! It's gone. To view the contents of a collection, select the desired collection in the Collections pane. You can organize collections hierarchically by dragging one collection into another to make the dragged collection a child of the collection you dragged it to. Figure 3.8 shows that Roma has now become a child of Italia.

FIG 3.8 Hierarchical capability of Collections simplifies organization.

Quick Collection (QC)

The QC is a temporary collection. You can use QC to assemble a temporary group of photos to work with from within in any module. To add a photo or photos to a QC you just need to select the photo and press the (B) key. The circle icon in the upper-right corner of the thumbnail (Figure 3.9a) becomes dark (Figure 3.9b) when that photo is added to the QC. You can view the QC in Filmstrip or in the Grid view. Even though this is a temporary collection, that doesn't mean it disappears when you turn off Lightroom. It remains there until you remove the photos or convert it to a permanent collection.

(a) (b)

FIG 3 9 Quick Collection indicator on thumbnail: a, not added to QC; b, has been added to QC.

> **NOTE**
> Are the photos in your QC missing? If you open QC or a regular collection and discover you are facing a blank screen that says **No photos selected**, press Ctrl+L to disable all of the filters and the photos will reappear.

Here is how to convert a QC into a collection:

1. Choose File, Save Quick Collection.
2. In the Save Quick Collection dialog box (Figure 3.10), type a name in the Collection Name text box.
3. If you select Clear Quick Collection After Saving, it clears the QC after it's saved as a collection. If you don't, the contents of the QC remain.
4. Click Save.

FIG 3.10 Save Quick Collection dialog box.

The Power of Keywords

Folders, collections, and the other tools work well but when it comes to managing a library of perhaps thousands of photos you will discover that being able to quickly find the exact photo (or photos) when you need it is, at best, a challenge. The key to maintaining an organization like this is applying keywords to your photos. You should have applied some basic keywords when you first imported these photos into Photoshop Lightroom. For example, when I imported the photos from the Barcelona shoot, I was able to add about 10 general all encompassing keywords. To be able to search the catalog effectively you need to take a few minutes to assign more specific keywords. Investing that time now will save you hours of searching later.

When I talk with photographers about keywords, they are considered the most important feature of Lightroom or the least important; there doesn't seem to be a middle ground on the topic. For any photographer that does stock photography, keywords are essential. Keywords (called Keyword tags in Lightroom) are words that describe the important contents of a photo. They help you identify, search for, and find photos in the catalog. Keyword tags are stored either in the photo file or with some proprietary camera raw files the keywords are stored in XMP sidecar files. The best news is that after investing the time entering all of your keyword information, this keyword data can be read by other Adobe applications such as Bridge, Photoshop, or Photoshop Elements. There are image viewers and other applications that support XMP metadata that can also read the keywords added by Lightroom, but the only way to be sure is to try them out on your favorite application to see they read the keywords.

Lightroom provides several ways to apply keyword tags to photos. You can type or select existing keywords in the Keywording panel, or drag photos to specific keyword tags in the Keyword Tags panel. In the Grid view, photos with keyword tags display a thumbnail badge (Figure 3.11).

All keyword tags in the catalog are viewed in the Keyword Tags panel (Figure 3.12). You can add, edit, rename, or delete keyword tags at any time. When creating or editing keywords, you can specify synonyms and export options. Synonyms confused a lot of us when it first showed up and it

Keyword Thumbnail

FIG 3.11 Keyword Thumbnail icon shows an image has keywords attached to it.

Keyword Tags panel

▼ Keyword Tags − +
.50 caliber 11
5th street objects 2
24 BIT 4
50 caliber 1
✓ abandoned 390
abstract 2
abstracts 2
acropolis + 31
active 1
adult 7
ADULTS 4
advice 1
aerial view 194
AFRICA 2
AFRICAN 1
after burner 3
agbar tower 3
▼ air show 18
 air show Burnet 5
 air show Burnet 2005 1
 air show Georgetown 2002 7
▼ aircraft 294
 airplanes 1
alley 2
altar 1
Altare della Patria 4
▷ alter 1
america 2
american 70
ammo box 1
ammo. 11
ammunition 0
ammunition 11

FIG 3.12 Keyword Tags panel showing a few of the many keywords.

continued to change. Synonyms are related words that you define for certain keyword tags. For example, when you enter the keyword **Boy**, the synonyms might include all of the following: child, male, toddler, and juvenile. This can be a huge help when applying keywords for a stock photo submission but otherwise it is pretty useless because you cannot search for synonyms as you can search for keywords. When you select photos containing keyword tags that have synonyms, the synonyms are only displayed when displayed in the Implied Keywords text box of the Keywording panel. We'll learn how to make them later in this section.

Adding Keywords to a Photo

You can use the Keywording panel of the Library module (Figure 3.13) to add keyword tags to photos by either typing a new keyword tag or applying keyword tags from a keyword set. You can also apply keyword tags to photos using the Painter tool which was called the Stamper tool in version 1.0.

To add a new keyword to a photo do the following:

1. Select the Loupe or Grid mode in the Library module.
2. Select a photo or from either Grid or Filmstrip select a group of photos to which you want to add a keyword.

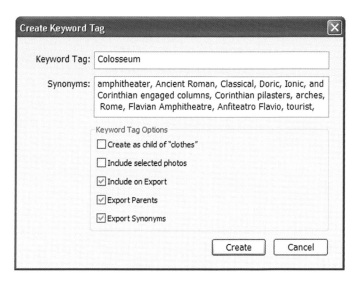

FIG 3.13 Keywording panel is used to add keywords to photos.

3. Open the **Keywording** panel in the right pane and ensure that **Keyword Tags** is set to **Enter Keywords**. Click the cursor inside the text box changing it from dark to white.
4. Type in the new keyword. If adding more than one keyword, separate each word with a comma.
5. When you are finished, press the Enter key. The keywords will be rearranged alphabetically and the box will become dark again.

> **TIP**
> Don't accidentally insert a period instead of a comma to separate keywords as Lightroom will treat the two words as a single keyword. For example, if you enter Rome.Italy Lightroom treats Rome.Italy as a single word.

Keywords and case

When you add a new keyword, Lightroom accepts the upper and lower case usage you enter and will change the case usage of all additional usages of the keyword. For example, let's say the first time you entered the keyword Oxford you accidentally had the Caps Lock on and you entered it as OXFORD. The next time you add the keyword Oxford to a photo Lightroom will change it to OXFORD. The only way to correct this is to right-click (Ctrl+click Mac) the keyword OXFORD in the Keyword Tag panel (in the Left pane). Choose Rename and correct the case.

A few more thoughts about how Lightroom views upper and lower case in keywords. Unlike earlier versions of Lightroom, version 1.1 is case insensitive. This means that Lightroom treats the keywords Spain, SPAIN, and spain

as being the same. In earlier releases it would have been treated as three separate keywords. So, if you already have Spain in your keyword list and you want to create a new keyword named SPAIN, Lightroom will display a message telling you the name already exists and to pick another.

The Keywording panel on the Right Panel shows keywords that are assigned to a photo. When multiple photos are selected an asterisk '*' appears to the right of any keyword that is not used in all of the selected photos. For example, If you select six photos with the keyword Washington DC but only one of the selected photos has the keyword White House, in the Keywording panel, it would appear as White House*, Washington DC.

Keep in mind that when you add keyword tags to photos, the keywords are stored in Lightroom, but the keywords aren't saved to the images unless the **Automatically Write Changes Into** XMP option is selected in the **Catalog Settings** dialog box. Before deciding to enable this setting (it is off by default for good reasons), I must point out that having it enabled can really slow down catalog operations. You will get better overall performance from Lightroom if you leave it off, and manually save the keywords to the photo files by selecting the photos and pressing Ctrl+S.

When drag is not a good thing

When you are in the Grid view, you can select one or more photos and then drag them to keyword tags in the Keyword Tags panel, or you can drag a keyword tag from the Keyword Tags panel to the selected photos. This method works great if you only have about 10 keywords in your list, but when you have several hundred keywords, you will spend more time scrolling up and down the Keywords Tags list than it takes to type the keywords in or select them from a keyword set.

> **TIP**
> Do you need a way to quickly jump to a specific location on the keyword list? Join the club, we all do. At this time the only way to navigate through the list is by using the scroll bar on the left pane or the scroll wheel on your mouse. Maybe in 2.0.

If you do use the drag-and-drop method to drag a thumbnail onto a keyword in the Keyword Tags panel to assign keywords make sure that you begin by clicking on the photo or one of the photos, if multiple photos are selected, and not by clicking on the border of the thumbnail. If you click on the border to drag an image, Lightroom will not do anything.

The limited power of keyword sets

The idea of keyword sets is great. By selecting a set you have a predefined set of keywords that allows you to quickly grab and assign the keywords to the

photos. Figure 3.14 shows an example of one of the preset keyword sets that ship with Lightroom 1.1. The limitation of the keyword set is the restriction of only nine keywords. Still, it's better than nothing. To use the keyword set, from any view select the photo, click a keyword tag from the keyword set in the Keywording panel.

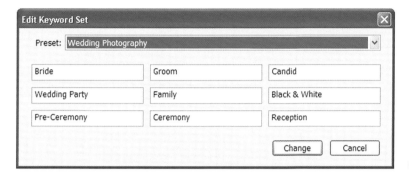

FIG 3.14 Predefined keyword set.

To create your own keyword set, open Metadata, Keyword set, Edit … (Figure 3.15). The currently selected keyword set will open which you can then modify and use Save Current Setting as a New Preset which opens another dialog box and you can give it a new name.

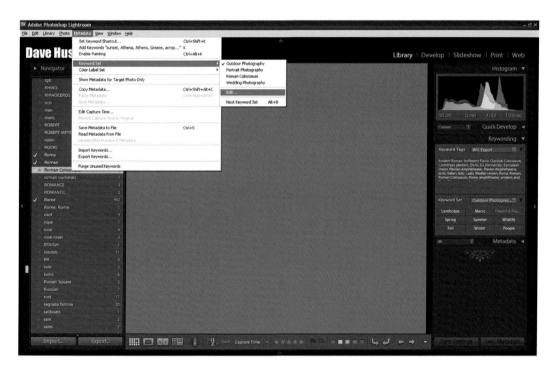

FIG 3.15 Access Keyword Set commands from Metadata menu.

Auto completion of keywords

As the size of your keyword collection increases, you will discover that Lightroom attempts to anticipate (based on your existing keywords) what you are entering for a new keyword as shown in Figure 3.16. This feature is both good and bad. The good part is that it speeds up the process of adding keywords to an image or set of images; it also ensures that your keywords are all spelled (or misspelled) the same way. The negative side of this feature is that you must pay close attention when entering keywords because it is easy to enter the wrong keyword when Lightroom's Mr. Helpful feature gets a little over eager and the wrong word gets entered; at the time I wanted to add the keyword *romance* to a scene and discovered a lot of photos had the keyword *Roman*.

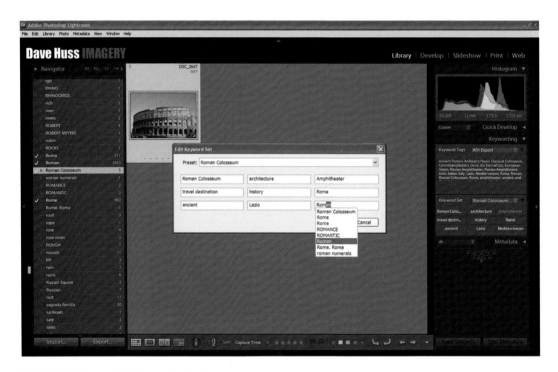

FIG 3.16 Auto-fill keyword help is both good and bad.

Cleaning up your keyword lists

One more point about keywords is the maintenance of the keyword list. After you have entered a lot of keywords you will discover some of your keywords slightly misspelled. The portion of Keyword list shown in Figure 3.17 is just such an occurrence. The keyword is architecture but there is also 'architecture. patterns' and 'archtecture.' The first one was caused when I used a period instead of a comma to separate the keywords. Lightroom accepted

it as a keyword. The second is just sloppy spelling. If I searched for keyword architecture, Lightroom would miss these two photos.

So, how do you fix this? It is a little convoluted to correct. Here is what you need to do.

1. Click on the keyword you want to correct. In this case, architecture. Both of the photos appear.
2. Select the photos and drag them into the Architecture keyword on the keyword list. Drag the photo, not the border. The destination keyword count will increase but the misspelled count will remain the same.
3. Right-click the misspelled keyword and select Delete. A warning box will appear asking you if you really want to do this. Choose Delete All and the misspelled keyword will disappear from the list.

Through normal catalog maintenance, some keywords will no longer have photos attached to them. The most common cause is when a photo with unique keyword is deleted. The keywords used by the photo still appear on the list. Look at Figure 3.17 and you will see a keyword that is grayed out (can barely be seen) with a 0 to the right of it, indicating that it is not assigned to any photo.

The good news is you don't need to visually examine you keyword list looking for orphans. In the Metadata menu select Purge Unused Keywords (Figure 3.18) and all of the keywords that are not being used will be removed from the Keyword list.

The Painter tool that Doesn't Paint

In Lightroom 1.0, you could apply keywords to multiple images in Grid view by using the Keyword Stamper tool. In Lightroom 1.1, the Painter tool replaced the Keyword Stamper tool. The Painter tool also allows you to apply keywords to photos, but you can also apply labels, flags, ratings, develop settings, metadata, and even rotation settings. You can click on individual photos or drag across multiple thumbnails as if painting. One gotcha with the Painter tool is that its action is a toggle. In other words, when you click on an image the first time, the contents of the Painter tool are applied to the image. If you click on the image a second time, it removes the same information from the image.

So, how can you tell if you are adding or removing? As you hover the mouse over an image that has not had the Painter tool applied the Painter tool cursor remains unchanged. After clicking on the image, the cursor changes into an eraser icon indicating that the next click on the image will remove what the Painter tool has added. Confused yet? Here is how it works.

Add or remove keywords using the Painter tool

1. In the Library module, open Metadata > Set Keyword Shortcut or Ctrl+Shift+K. This opens the dialog box. Any word that you type into this field will be applied by the Painter tool. Keywords must be separated by commas.

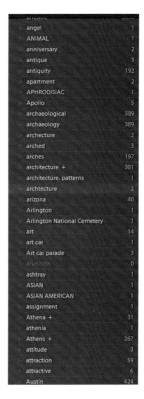

FIG 3.17 Slight keyword misspellings can impair word searches.

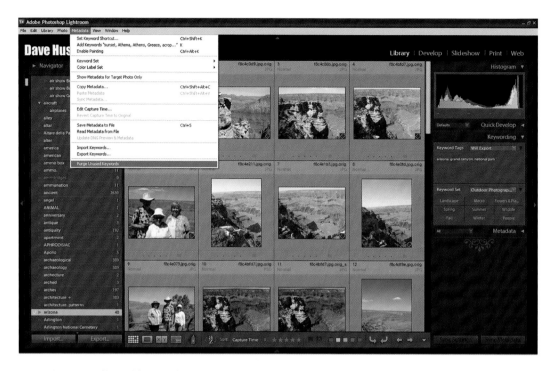

FIG 3.18 Purging unused keywords keeps your keyword list tidy.

TIP
Any existing keywords in the Keywords panel (left pane) that are added to the Keyword Shortcut field have a + sign appear to the right of its name. If the Keyword Shortcut field is blank, none of the keywords in the Keyword Tags panel have a + sign next to them.

2. Once you've specified the keywords for the keyword shortcut, Choose Metadata, Enable Painting.

NOTE
If the Painter tool does not appear in the toolbar, click on the Select Toolbar content down arrow at the far right side of the Toolbar and choose Painter from the toolbar menu.

3. In the Library module, select the Grid view (G), and click the Painter tool icon in the toolbar. When the Painter tool is enabled, the pointer becomes a painter icon and the Painter icon is no longer visible in the toolbar.
4. In the toolbar, choose Keywords from the Paint menu (figure). The Painter tool will use the contents of the Keyword Shortcut or you can type the keyword or keywords you want to add or remove in the toolbar field.

5. To apply a keyword shortcut, click the photo using the Painter tool and to remove the keywords from a photo, click or drag the Painter tool over the photo containing the keyword tag, and then click.

6. There are several ways to disable the Painter tool. You can click the circular well in the toolbar. When disabled, the Painter icon becomes visible in the toolbar. You can also disable it by pressing the ESC key or clicking the Done at the bottom right of the Toolbar. There are probably even more ways but I figure three is enough.

Keyword Searching

After going to all of this work to add keywords, it only makes sense to make use of them. The simplest way to find a photo by its keyword is to open the Keyword Tags panel in the Left pane, locate and select the desired keyword from the list and all of the photos that have the keyword instantly appear. The advantage of this method is all you have to do is pick a word from a list. What if you wanted all of the photos containing either one keyword or another? Simply click on the first keyword and then Ctrl-click on a second keyword. The selection that appears represents all photos containing keyword 1 or keyword 2.

The Find panel (also in the Library, left pane) can find any photo based upon keywords, filename, and title, to name a few. Operation of this panel is self-evident but there are a few points to consider. The search engine in Lightroom is not Google. You know how when you misspell a name in Google, it takes pity on you and asks if you are trying to find (word spelled correctly)? If you misspell a search word, Lightroom may not find it. If you are not sure of the spelling, either find it on the Keyword Tags list or type in the part that you are sure about and change the Rule: to contains. For example, if you weren't sure of the correct spelling of Parthenon, you could use the Contains rule and type in 'Part' and Lightroom will show you all of the photos that contain the search term Part. In my library the search produced 72 photos with the keyword **Part**henon and 2 photos that had the keyword a**part**ment.

In version 1.1 they added the ability to locate empty fields. This is outstanding. So now, if you want to discover all of the photos that have no keywords assigned to them, choose Text: Keywords, Rule: Are Empty. Every photo that has no keywords assigned appears. You can also search for photos without captions, titles, etc.

Metadata Browsing

The great thing about metadata is most of the fields are filled in for you by your camera. With the Metadata Browser you can search for any field and like the Keyword Tags you only need to click on the metadata field and all of the fields that match the contents of the one you selected appears. I must confess

that this seemed like something an Adobe engineer cooked up because he/she was bored. I couldn't see any practical use for it. I was wrong, really wrong. Here is just one example. I wanted to find all of the photos I took with my 10.5-mm fisheye lens. All I had to do was open the Metadata Browser in the Left pane of the Library module, open Lens and choose the lens from a list of lenses.

What you search for will be dependent on the type of work that you do, but to date, here are a few ways I have used the following:

- *Camera*: This is the quickest way to find all of the work of another photographer who worked a wedding with me. He was shooting a Canon EOS and I shoot with Nikons.
- *Lens*: This is especially handy when identifying photos taken with specialty lenses.
- *Format*: Again, very handy. Here is an example: I wanted all of the raw files I shot.

Now let's discuss catalogs.

When Lightroom 1.0 was used, it maintained its image Catalog in a structure called a Library (which had nothing to do with the Library module). There wasn't a good way to move all of the work from a notebook computer that you took on location with you to your master library that you maintained in the office. With the release of 1.1 this has all changed. The following sections show how to manage the new catalog structure in 1.1.

Exporting and Importing Catalogs

If you're like me, you have a master Lightroom catalog of images (backed up, of course) on your home computer. But when you're out on the road, taking photos of exotic locales, you may be creating catalogs in Lightroom, tagging, flagging, and rating your photos, and perhaps making adjustments at the end of the day on your laptop computer. When you return home, you don't want to lose all that work you've done, and fortunately you don't have to. You can export a catalog (with all its images and changes) from one computer and import them into a catalog on another – and never lose any of your hard work. Here is how you go about that.

Exporting a Catalog

To export a catalog, choose File | Export as Catalog to open the (you guessed it) Export as Catalog dialog box (see Figure 3.19).

Fill in the name of the exported catalog in the File field. This name is used as the name of the folder where all the contents of the catalog are stored. If you are going to move the catalog (and images) to another computer, leave both the Export negative files check box and Include Previews check box selected.

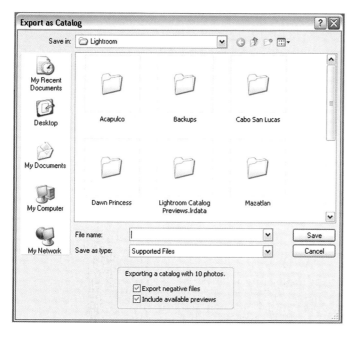

FIG 3.19 Specify the name of the exported catalog in the Export as Catalog dialog box.

NOTE
If you are going to import the catalog into an existing catalog on the same machine, you don't need to select these two check boxes.

Finally, click Save to start the export process.

NOTE
There is a 'gotcha' to watch out for when exporting as a catalog: only selected images are exported. Thus, if you happen to have a single image selected when you begin the export, you'll only export that one image. If you want to export everything in the catalog, make sure nothing is selected (or everything is).

Importing a Catalog

To import a catalog and merge it with an existing catalog, open the catalog you want to merge the photos into in Lightroom. Then do the following steps:

1. Choose File | Import from Catalog to open the Import from Lightroom Catalog dialog box (see Figure 3.20).

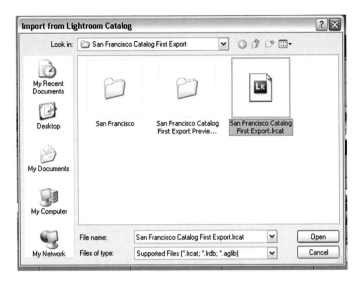

FIG 3.20 Find the catalog that you want to import in the Import from Lightroom Catalog dialog box.

2. Navigate to the catalog you want to import and Open. This opens the
 Import from Catalog dialog box (see Figure 3.21).

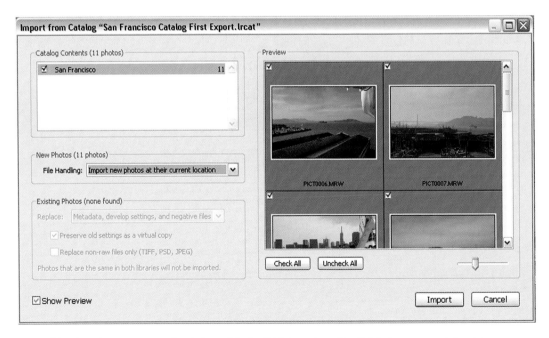

FIG 3.21 Select the catalog images to import from the Import dialog box. This is the version you'll see if all the images are new to the catalog.

3. Select the images you want to import. If you don't see the previews, select the Show Preview check box.
4. Adjust the settings in the Import dialog box as described below and click Import to add the photos to the current catalog.

NOTE
Don't get upset if you see only your new photos in the catalog. The default setting for Lightroom is to show you only the results of your previous import – exactly the images you just imported. To see all the images in the catalog, click All Photos in the Library panel on the left side of the screen.

Adjust import settings for new images

You can set the file handling controls for new photos in the New Photos section of the Import from Catalog dialog box. Choose whether to import the images at their current location or to copy them to a new location. If you choose to copy them to a new location, the Copy to control appears (see Figure 3.22). Click the Choose button to specify the target folder to copy the photos to.

Choose to copy images to a new location or leave them where they are

Click to specify the new image location

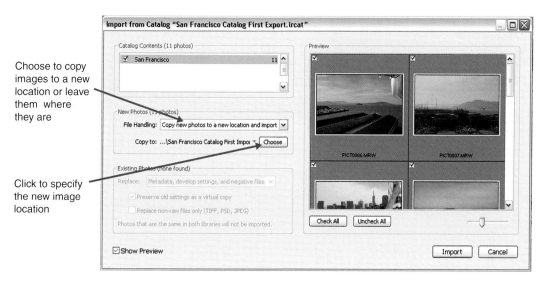

FIG 3.22 Use the new controls to copy images to a new location.

TIP
Of course, if the photos are on a USB drive or CD/DVD, you'll definitely want to copy them to a new location on your hard drive.

Adjust import settings for existing images

You can adjust what will be imported for images which already exist in the target catalog using the controls in the Existing Photos section of the Import from Catalog dialog box (see Figure 3.23). These options are available only if duplicates are detected.

Indicates that the reimported images is different from the original

FIG 3.23 Adjust the parameters for existing images in the Import from Catalog dialog box.

NOTE
If a photo is identical to a photo already in your target catalog, it will be grayed out and unavailable for import.

The first thing you need to decide is what to replace in the target catalog. You can select from a combination of choices in the Replace drop-down list:

- *Metadata*: Replaces metadata values that have been assigned to the image in the target catalog. If the source catalog metadata values are different from the metadata values in the target catalog, the target values will be overwritten.

- *Develop settings*: Replaces the Develop module's settings (white balance, light tones, shadows, cropping, etc.) in the target catalog. If the source catalog Develop settings are different from the Develop setting in the target catalog, the target values will be overwritten.
- *Negative files*: Replaces the image files in the target catalog with those in the source (imported) catalog. Note that since Lightroom's changes are non-destructive, you normally don't need to replace the negative files. However, if you modified the original file in another program from within Lightroom, you will need to reimport the negative file.

NOTE

If you choose Nothing from the Replace drop-down list, the Import proceeds, but only new images are imported.

If you have made changes in the original catalog and are reimporting images with new Develop settings or metadata, you have the option to preserve those settings as a 'virtual copy'. To do so, select the Preserve old settings as a virtual copy check box. Essentially, this means that you'll appear to have two copies of the image in your Lightroom catalog (see Figure 3.24). What you actually have is one copy of the negative file itself, and two sets of non-destructive changes. You can then proceed to modify each 'virtual copy' independently, changing the metadata and Develop settings.

Lines indicate the first thumbnail in the set

Lines indicate the last thumbnail in the set

This number indicates how many virtual copies of the image are in the catalog

Indicates that this is the original settings preserved as a virtual copy

FIG 3.24 When you preserve your original settings as a copy, you'll see two versions of your image.

Lightroom provides some additional information to help you sort out the imported results:

- *Indicator of a virtual copy*: The virtual copy displays a 'folded page' icon in the lower left corner to let you know that it was the original, preserved when you imported a new version.

- *Number of copies*: If there is more than one copy of the image in the catalog; a number appears in the upper left corner of the most current version to tell you how many copies there are.

If you hover your mouse pointer over either a virtual copy or the most recent version, you'll see a counter (see Figure 3.25). The counter numbers are from 1 (the most recent version) to *n*, where *n* is the number of copies. The sets of thumbnails are displayed in dark gray with a small set of lines in either the left margin (the first thumbnail) or the right margin (the last thumbnail).

FIG 3.25 Hover your mouse over a thumbnail to see a counter of the number of versions of an imported image.

If you chose to replace the negative files in the target catalog, you can limit this option to replacing just the non-raw files. To do so, select the Replace non-raw files only (TIFF, PSD, JPEG). As stated earlier, you only need to replace the negative files if you made changes to the original in an external editor. This is really possible only with non-raw files, so it makes sense to select this option and speed up the import by only replacing those files.

Lightroom and Network Shared Drives

With the increasing popularity of networked systems (even in small businesses) and inexpensive network attached store (NAS) drives a commonly asked question is 'Can I store my library on a network drive with Lightroom 1.1?' No, this is still not supported. There are too many variables in a network configuration to guarantee that the library Catalog will not become corrupted. Don't lose heart, Adobe has expressed interest in it and I think future releases may include it.

Where Lightroom Keeps its Files (Windows)

Here is some important technical information that you will need to read when you find yourself digging around inside you computer trying to rebuild or otherwise work with Lightroom.

The Photoshop Lightroom application is the Lightroom.exe file, located in the Program Files\Adobe\Adobe Photoshop Lightroom folder. Preferences are located in the Lightroom Preferences.agprefs file, located in the Documents and Settings/[username]/Application Data/Adobe/Lightroom/Preferences folder.

The Catalog backups are in the Backups folder located in the Documents and Settings/[username]/My Documents/My Pictures/Lightroom folder. Each backup file name begins with the date of the backup and includes a random number before the actual file name, which is Lightroom Catalog.LRCAT. An example of a file name is: 2007-01-19 1221 Lightroom Catalog.LRCAT. Both installed and user-created presets and templates have file names ending in .lrtemplate, located in their appropriate folders under the Documents and Settings/username]/Application Data/Adobe/Lightroom folder. Registration information is located in the Windows registry, in the HKEY_LOCAL_MACHINE/ Software/Adobe/Lightroom/1.1/Registration key folder. Think hard before venturing into the Registry.

> **NOTE**
> There is no lock file on Windows. The application cannot be opened by more than one person simultaneously, and libraries cannot be opened on a network share, which is why Adobe saw no reason to have a file that locks the application.

Where Lightroom Keeps its Files (Mac)

I almost didn't include this since most Mac users eschew technical information like this. Anyhow, the Photoshop Lightroom application is the Adobe Lightroom.app file, located in the Applications folder. The preference file is the com.adobe.Lightroom.plist file, located in the [username]/Library/Preferences folder. The following Photoshop Lightroom Catalog files are located in the [Username]Pictures//Lightroom folder.

- Lightroom Catalog.LRCAT is the Catalog and the Lightroom Catalog.LRCAT. lock (the file that prevents data from being overwritten inadvertently).
- Lightroom Previews.lrdata (the file that holds the preview data assigned to your photos).
- The Catalog backups are in the Backups folder located in the Pictures/ Lightroom folder. Each backup file, named Lightroom Catalog.LRCAT, is

in its own folder that is named with the date of the backup and a random number. For example, a folder could be named 2007-01-19 1221.

- Installed and user-created presets and templates have file names ending in .lrtemplate, located in their appropriate folders under the [username]/ Library/Application Support/Adobe/Lightroom folder. Registration data is in the Library/Application Support/Lightroom/Lightroom 1.1 Registrations folder.

Pursuing Perfection: Working with the Quick Develop and Develop Module

After you have imported your photos and sorted out the good from the bad and the ugly you are now faced with the job of enhancing the images that you will deliver to your client. Ideally, all of the photos were perfect. Your flash always fired perfectly, none of the people in the photos had red-eye, and the subject didn't break out with skin problems 5 minutes before the shoot. That describes what all of the photo shoots look like that are shot in the City of Oz. Unfortunately, the rest of us shoot in the real world and all of these things can and do happen.

Unleashing Quick Develop

Photoshop Lightroom has a lot of photo editing tools that are designed to get the job down in the least amount of time. They are not designed

to photo realistic art like Bert Monroy, make panoramas, or accomplish extensive retouching (like making the groom look less like Shamu). It is about enhancing and correcting images and doing that not to just one, but to multiple images at the same time, which is very comforting as you begin work on the several hundred photos that you picked out of the 1500 that you shot. Before exploring the Develop module, we must first return to the Library module.

Before beginning, let's discuss the subject of prejudice and how it can impede your workflow. Prejudice? I am referring to the idea that all automatic tools in photo editing applications are tools for non-professionals and are eschewed by the true professionals. In fairness there was a time that was true, but automatic tools have made great progress in the past few years and you do yourself a disservice if you don't at least try them now and again. The reason I got on this soapbox is because our first area of image enhancement is done in the Quick Develop panel of the Library module. I would hate to think that you would miss out on the benefits of this integral part of the Lightroom workflow because of personal prejudice.

Quick Develop

Without exiting Lightroom, there are two places where you can adjust the exposure, clarity, and other basic tonal and color corrections. In the Library module it is the **Quick Develop** panel, and in the Develop module a more advance set of controls is found in the right pane that includes the Basic panel and several other panels. Don't let the name Quick Develop deceive you; it contains many of the same tools found in the Develop module. The advantage of Quick Develop is that you can apply corrections at the same time you are sorting through the photos without leaving the Library module – a timesaver. Let's go through how the Quick Develop works:

1. After importing photos in the Library module, double-click the first photo to open it in Loupe mode. To produce the greatest amount of space on the display to view the photo, close the other panels, Toolbar, and Filmstrip only leaving the Quick Develop panel open, appearing in the right pane of the Library module (see Figure 4.1), right below the Histogram panel.
2. When the Quick Develop panel opens it appears not to have much to offer. When you click the down-facing double arrows shown in Figure 4.2, the controls expand to reveal a wealth of additional controls. The top section (presets) lets you apply Develop presets, select crop presets for standard photo sizes (essential), and you can even switch between color and grayscale. White Balance allows you to apply presets or manually adjust the color temperature using sliders. Tone Control provides the main exposure controls and color saturation. If you don't see all the choices shown here, click on the down-facing double arrows along the right side of the Quick Develop panel to expand each section.

FIG 4.1 The Quick Develop panel of the Library module.

Presets

White Balance

Tone Control

FIG 4.2 The Quick Develop panel expanded.

3. The first step in image correction is a matter of personal choice. One school of thought believes that you should adjust exposure first and correct color balance second while other believes the exact opposite. We will begin by correcting the exposure. Pressing the Auto Tone button applies an automatic adjustment limited to Exposure, Brightness, Contrast, and Blacks settings. Many photographers have commented that often times Lightroom's Auto Tone pushes the image too much making it too bright. While the Histogram shown in Figure 4.3 says the distribution is acceptable, this is a romantic moment meaning it shouldn't have the same level lighting used for forensic photography. Still, I recommend giving Auto Tone a try as a first step. If you don't like the results, you can always press Ctrl+Z (Mac Command+Z) to Undo it.

FIG 4.3 Auto Tone Corrections may be too bright.

4. After Undoing Auto Tone the Exposure buttons were used to increase the lighting by 1.33 stops (as shown in Figure 4.4). The outer Exposure buttons represent increments equivalent to adding or subtracting a single f-stop. The inner buttons apply changes that are the equivalent of 0.33 (1/3) of a stop.

5. The Color Temperature in this photo is acceptable. Figure 4.5 shows some of the color balance presets that may be available. Results of the Auto color

FIG 4.4 Manual exposure adjustment achieves the desired effect.

FIG 4.5 The number of White Balance presets selections that are available camera and format dependent.

setting (Figure 4.6) looks good in part because the background is a neutral gray giving Lightroom a good reference to work with. This photo was taken with multiple strobes so the Flash preset should be spot on, but in fact it produces undesirable color cast. The point is that if there are presets available, just because something says flash, daylight, or incandescent doesn't mean it will provide the correct color adjustment. Also, the number and type of White Balance presets that are available are dependent on the camera and format being used. Raw format usually provides the greatest selection.

FIG 4.6 The Auto White Balance setting works well when the scene contains neutral colors.

6. At this point the photo looks ready for prime time (Figure 4.7). There are a lot of other tweaks we could apply, but the truth is the photo looks good enough to please the customer and we have in the space of 30 seconds

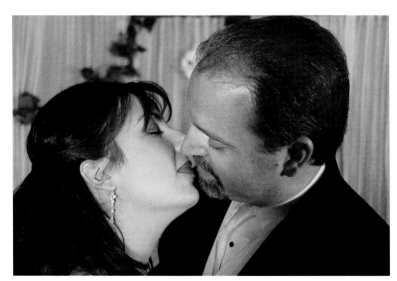

FIG 4.7 Flash White Balance setting doesn't necessarily provide the best color correction for flash.

made this into an acceptable image for the client. However, one thing is missing. The ratio of the camera that was used to take the photo is 3 × 2. If we are going to make large prints with this image, we need to crop it to fit standard photo paper sizes. Open the Crop Ratio box and pick the one of the many crop ratios from the list. For the image in Figure 4.8b, 8 × 10 was

FIG 4.8a Lightroom provides crop presets in standard photo sizes.

Image area lost when printed as an 8 × 10

FIG 4.8b Selecting an 8 × 10 crop ratio shows how much of the image is lost when cropped.

83

selected. Notice how much of the edge was lost on an 8 × 10 crop. Just a reminder, the original has not been cropped – the joy of non-destructive editing.

7. With the White Balance, Exposure, and Crop acceptable, these settings can be applied to all of the other photos that were taken during the same session. With the corrected image selected in Grid mode, Shift- or Ctrl-select (Mac Command-select) all of the other photos that were taken using the same setup (as shown in Figure 4.9).

FIG 4.9 Select all the photos that were taken with the same lighting.

8. Next, press the Sync Settings button at the bottom of the Right panel opening the Synchronize Settings dialog box (Figure 4.10). The default setting has most of the settings checked. While this works, it is best to check only the settings that you changed and click the Synchronize button. All of the White Balance and Exposure corrections (crop was not checked) are applied to all of the other images in that section of the shoot.

9. This is a good time to point out the tiny icons that appear in the lower-right corner of the image. It provides a quick and easy way to tell if the image has keywords, has been cropped, or has received adjustments in either the Quick Develop or the Develop module. These icons are visible in either Grid mode or the Filmstrip.

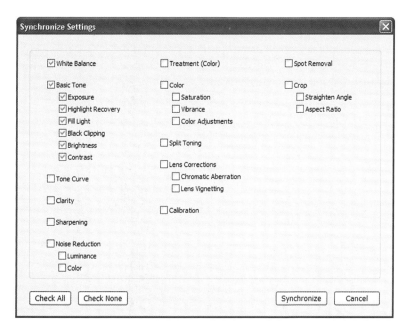

FIG 4.10 The Synchronize Settings dialog box is used to apply Quick Develop settings to multiple images.

10. Consider running the Impromptu Slideshow (Ctrl+Enter/Mac Command+Enter) to view all of the images you just synchronized to ensure that none of the corrections pushed the photos either too much or not enough (Figure 4.11).

FIG 4.11 Icons provide a visual indication of the processing status of a photo.

The Tone Controls and What They Do

While some of the controls in the Tone Control portion of the Quick Develop pane may be familiar to you, others may be new. Here is a brief opinionated summary of what each control does:

- *Exposure*: This control sets the overall image brightness; it produces its greatest effect in the high values. This is why it has a tendency to push the highs of the image a little too much, but for some situations it works well. Figure 4.12a is the original backlit photo. After applying Auto Tone, Figure4.12b shows the subject coming out of the shadows.

FIG 4.12a Original image is backlit leaving the subject in the dark.

- *Recovery*: This control reduces the tones of extreme highlights and attempts to recover highlight detail lost because of camera overexposure. This feature will not remove or reduce glare from a flash or the sun. Lightroom can recover detail in raw image files if only one or two channels are clipped but if an area is a complete blowout, no amount of recovery setting can restore the lost details. Also be careful that you don't apply too high of a recovery setting as it can turn a soft glare into a bright well-defined blob.
- *Fill Light*: This control lightens the shadow areas of an image to reveal more detail while maintaining blacks. Take care not to apply too much Fill Light as it tends to reveal image noise. In Figure 4.13 Fill Light was used to bring the

FIG 4.12b Auto Tone has improved the image.

FIG 4.13 A combination of Fill Light and Recovery brings the subject out of the shadow without blowing out the background.

subject on the left out of the shadows and Recovery was used to prevent the bright background from getting any brighter.

- *Blacks*: This control defines which image values are mapped to black. Using the buttons on the right increases the areas that become black. Applying this control affects image contrast. The Blacks control's greatest affect is in the shadow region, with much less change in the midtones and highlights.

NOTE
Users of Brightness and Contrast in previous versions of Photoshop were aware that these adjustment tools worked poorly. The Brightness and Contrast tool in Lightroom works great and it is recommended that users experiment with them to see just how well they work.

- *Brightness*: This control adjusts image brightness, mainly affecting midtones much like the gamma on Photoshop Levels. The recommended procedure is to establish the overall tonal scale by setting Exposure, Recovery, and Blacks. After that, set the overall image brightness. Large brightness adjustments can affect shadow or highlight clipping, so you may want to readjust the Exposure, Recovery, or Blacks slider after adjusting brightness.
- *Contrast*: This control increases or decreases image contrast, mainly affecting midtones. Unlike the contrast controls in previous Adobe products you can apply Contrast without fear of dragging your photo into darkness. When you increase contrast, the middle-to-dark image areas become darker, and the middle-to-light image areas become lighter.
- *Clarity*: This is a new control that is often described as adding 'punch' to an image. In fact, Clarity enhances the feeling of depth to an image by increasing local contrast with a touch of Unmask filter thrown in for good measure. When using this setting, it is best to zoom in to 100% or greater to accurately evaluate its effects. To maximize the effect, increase the setting until you see halos near the edge details of the image (i.e., the USM making its presence known), and then reduce the setting slightly. As good as this control is, it is not recommended for portraits unless the subject wants their wrinkles emphasized.
- *Vibrance*: This control is essentially saturation with an internal limit to prevent it from oversaturating the image. It does it by adjusting the saturation so that clipping is minimized as colors approach full saturation, changing the saturation of all lower-saturated colors with less effect than on the higher-saturated colors. Vibrance also prevents skintones from becoming oversaturated.
- *Saturation*: This control adjusts the saturation of all image colors equally from −100 (monochrome) to +100 (double the saturation).

TIP
Double-clicking any of the adjustment control names resets the value of the adjustment to zero.

To finish up the image of the fairies, the White Balance was set to Auto to correct a slightly cool color cast before applying Clarity and Vibrance. Figure 4.14a is the original, Figure 4.14b is the corrected photo.

FIG 4.14a The original photo.

FIG 4.14b Using several of the tools in Quick Develop, the image has been improved in record time.

Now, let's move on to the Develop module and see what other tools are available.

The Develop Module

The Develop module contains a souped-up version of the Quick Develop module providing just about everything you need for enhancing and correcting an image (Figure 4.15). The primary controls are located in the right panel section. At the top is the Histogram which, unlike the passive one in the Quick Develop module, is interactively tied to the controls in the **Basic** panel immediately below it. The controls in the Basic panel provide the same controls as the buttons did in the Quick Develop module except that these are sliders making them more flexible. It is your first stop for basic image tonal and color adjustments.

FIG 4.15 The right pane of the Develop module contains a lot of image adjustment and correction tools.

Interactive Histogram

Odds are that you never have adjusted an image using a histogram. The upper corners of the Histogram panel are clipping indicators. The black (shadow) clipping indicator is on the left and the white (highlight) indicator is on the right. You turn each of them on independently by clicking on them. When they are on, the shadow and highlight clipping appears in the image as blue (shadow) and red (highlight) as shown in Figure 4.16. Clicking and dragging

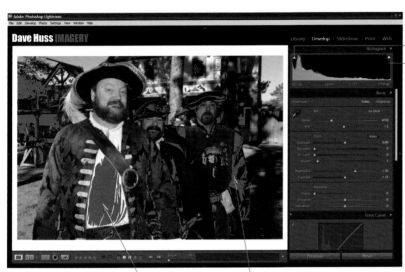

Shadow clipping indicator
Highlight clipping indicator

Red highlight clipping Blue-shadow clipping

FIG 4.16 The right pane of the Develop module contains an array of image adjustment and correction tools.

the shadow portion of the histogram and dragging it to the right moves the Blacks slider and the Shadows clipping indicator (blue) change. As you drag the highlights portion of the Exposure or Recovery sliders watch the highlight (red) clipping indicator. Either a red or blue clipping indicator means one or two channels are clipped.

Using the Compare View

An important feature in the Develop module is the Compare view. It is selected by clicking on the Compare View icon in the Toolbar. When selected it displays the before and after previews so you can see how your adjustments compare with the original. You can also change how the Compare View displays by clicking the down arrow to the right of the icon. The list of choices is shown in Figure 4.17. The Split view divides the photo in half (half before and half showing after) whereas the before/after shown is the other option.

Fine Tuning the White Balance

You can adjust the White Balance of a photo to reflect the lighting conditions under which it was taken – such as daylight, tungsten, flash, cloudy overcast day, to name a few. We already discussed the White Balance preset option in the Quick Develop section of this chapter. In the Develop module there is a tool that lets you click on an area in the photo that you want to specify as a neutral color. Lightroom adjusts the White Balance setting to calculate the color cast, and then you can fine-tune the color temperature (White Balance) using the sliders provided.

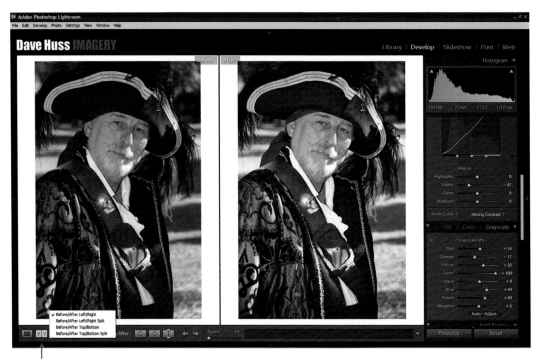

Compare View Icon

FIG 4.17 The Compare view provides a real-time before and after previews of your adjustments.

1. In the Basic panel of the Develop module, click the White Balance Selector tool to select it, or press the W key.
2. Move the White Balance cursor into an area of the photo that should be a neutral light gray. Avoid spectral highlights (blowouts) or areas that are 100% white. If you cannot find a light neutral color, find a darker one.
3. As you move the cursor around the Show Loupe continually displays a close-up view of the pixels the cursor is hovering over and RGB values of the pixel under the White Balance Selector. In practice, this is more information than you need. Use this display to find the most neutral pixels.

> **TIP**
> By default the Auto Dismiss is enabled – don't change it. This setting prevents Lightroom from combining all of the samples that you make and forces the White Balance Selector tool to flush out the last sample automatically after clicking on the photo and change into the Hand or Zoom tool.

4. The Navigator displays a preview of the color balance as you stop and hover the White Balance Selector over different pixels. This can be a very

handy feature if you watch it while you are moving the cursor around. Don't move the cursor around too quickly; this gives the preview in the Navigator time to generate the preview.

5. When you find a neutral area, click on it. If you don't like the White Balance correction, click Undo and try another spot.

TIP
For the best results, have one of the subjects hold a calibrated color card or 18% gray card while you take their photo for later use as a reference for White Balance adjustments. These cards are available at most photo stores.

Tone Curve Panel

Below the Basic panel is the Tone Curve panel (see Figure 4.18). If you used the Tone Curve tool in Photoshop CS2 or earlier, you are in for a pleasant surprise. While the Tone Curve is considered the ultimate tonal power tool, it is also difficult for most people from this planet to use. The Tone Curve in Lightroom is much easier to use while still providing a more advanced degree of control over the image tones than can be accomplished using the Basic panel.

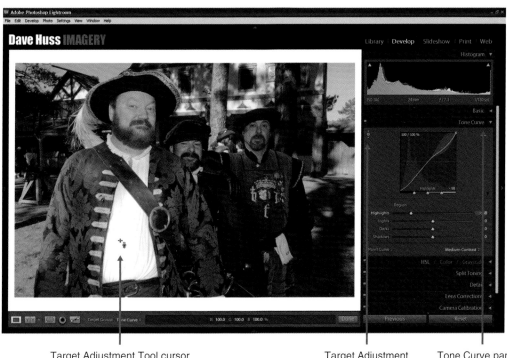

Target Adjustment Tool cursor Target Adjustment Tone Curve panel
 Tool (TAT) Icon

FIG 4.18 Lightroom provides the power of the Tone Curve without the complexity.

The key to the improved usability of the Tone Curve is the addition of the Target Adjustment tool (TAT) as shown in Figure 4.19. After activating the TAT it continually reads the pixels as you move the cursor over the image. By clicking

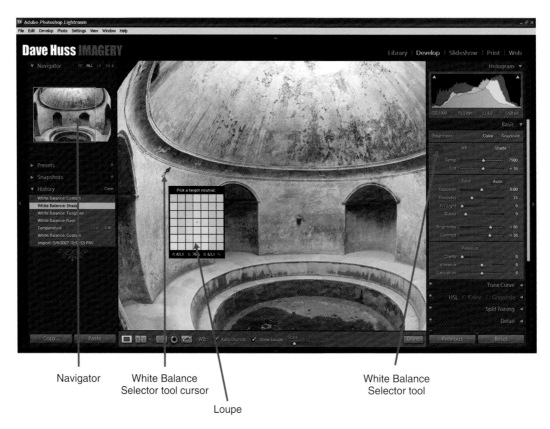

Navigator White Balance White Balance
 Selector tool cursor Selector tool

Loupe

FIG 4.19 The White Balance selector tool can accurately correct color casts.

on an area of interest and dragging the mouse either up or down you can lighten or darken only those tones within the range. This same interactive tool is used when making Hue, Saturation, and Luminosity (HSL) and Grayscale panel adjustments. Figure 4.20a shows the original image, and Figure 4.20b shows how using the Tone curve selectively improved the image by lightening the shadow regions and keeping the white shirt from being clipped any more than it already was.

Below that is the HSL/Color/Grayscale panel. The HSL section provides similar controls to the Hue/Saturation adjustment in Photoshop. These settings allow you to adjust separately the hue, saturation, and luminance components of an image. In Figure 4.21, the HSL section of the panel was switched to Hue by clicking on the word Hue. After clicking on the TAT icon the cursor was placed on the blue shirt on the before view and dragged downward. The result

FIG 4.20a Before applying the Tone Curve.

FIG 4.20b After correcting image tonal problems using the Tone Curve.

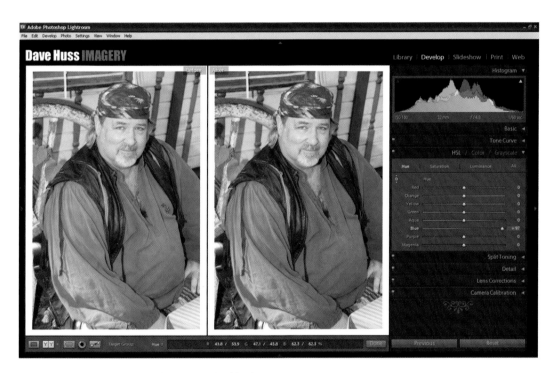

FIG 4.21 One stroke with the HSL TAT tool changes the color of the shirt.

appears on the right (after) view. While this looks impressive, there are a few limitations to this magic. When the cursor was placed on the blue shirt and clicked, that determined the initial starting color range. If you look at the HSL panel you will see that it resulted in the blue being pushing to its extreme (180 degrees). Had the subject been wearing a red shirt, there would have been a problem since the skin color has a lot of red in it and the skin color would have been shifted as well as the shirt color.

While changing colors of objects in a photo appears to be cool stuff, the fact is you don't often have occasion to change colors on photos. Figure 4.22 shows a problem that does occur quite often. The rose was one of the many laid against the Vietnam Memorial Wall everyday in Washington DC. The red color in the rose is oversaturated and the green (because it was a cloudy day) looks a little desaturated by comparison.

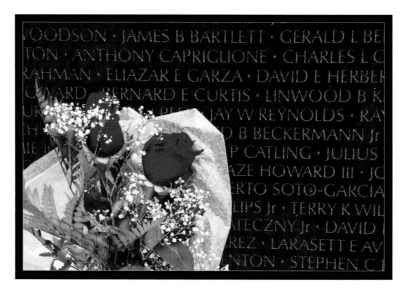

FIG 4.22 The reds in the rose are oversaturated.

Here is how to correct the problem.

1. In the HSL panel, select Saturation and click on the TAT.
2. Click the TAT cursor. Zoom in (Z). Click on the reddest part of the rose and drag it downward until the detail begins to reappear (shown in Figure 4.23). It will seem a little desaturated but we'll fix that in a moment.
3. Now click on the green leaves and drag the mouse up increasing the saturation of the green, making it appear healthier.
4. Click on the red of the rose and carefully push it back up until the detail begins to disappear. The corrected image is shown in Figure 4.24.

Split Toning

If you have ever worked the Hue/Saturation controls in Photoshop, you are familiar with the Colorize option. It changes a grayscale image into one composed of a single color. The result looks a lot like a duotone. The Split Toning panel is different in that it colorizes the shadows and highlights of an image separately (the Split Toning controls actually work nicely on color images as well as black and white). Figure 4.25 shows an example of applying Split Toning to an image to create an effect. Figure 4.26 shows how Split Toning

FIG 4.23 Only the reds in the rose are slight desaturated.

FIG 4.24 Detail restored to the reds and the greens appear healthier.

FIG 4.25 Split Toning produces a Duotone appearance on grayscale images.

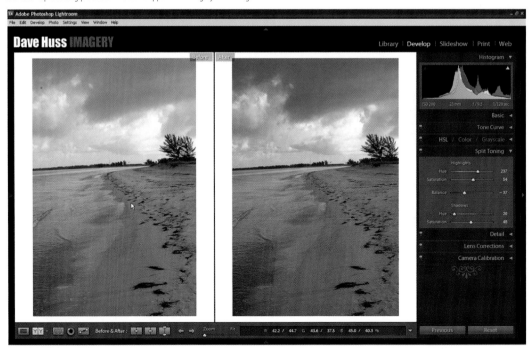

FIG 4.26 Dull colors can be punched up for unique effects using Split Toning.

can be applied to a beach photo taken on a hazy morning and by loading up the highlights and shadows with color, it produces a retro-looking color image.

The Detail panel lets you to enhance the sharpness of an image. Lightroom also includes controls for suppressing the color noise and luminance noise in an image. While they can reduce the noise, it is usually at the expense of image detail. The Lens Correction panel controls can correct common lens defects such as the chromatic aberration responsible for color fringing as well as lens vignetting.

The Power of Presets

Presets provide a way to save a group of settings and apply them to other photos. Once you create and add a preset to the Presets panel in the Develop module, it remains there until you delete it. In addition to the default Presets provided by Adobe, there are many more presets available on Lightroom sites on the Web for free. Figure 4.27 shows one effect produced using a default

FIG 4.27 Presets lets you apply multiple Lightroom settings with a single stroke.

Preset. Figure 4.28 shows more effects that were created using other Presets that were downloaded from the Web.

(a)

(b)

(c)

FIG 4.28 A montage of effects created using various Presets downloaded on the Internet.

(d)

FIG 4.28 (Continued)

Retouching and Correcting Flaws

This last major section covers the tools used to cover up everything from zits to sensor spots on the camera and crop and straighten out photos that need it.

Crop, Straighten, or Both

The toolbar in the Develop module contains tools and controls for cropping and straightening photos. Both Lightroom crop and straighten controls operate by first setting a crop boundary, and then moving and rotating the image in relation to the crop boundary.

As you adjust the crop overlay or move the image, Lightroom displays a grid of thirds within the outline to help you compose your final image (as shown in Figure 4.29). As you rotate an image, a finer grid appears to help you align to the straight lines in the image.

Cropping an Image
1. In the toolbar on the Develop module, either click the Crop Overlay tool in the Toolbar or press the R key.
2. An outline with adjustment handles appears around the photo (Figure 4.29).
3. Drag in the photo using the Crop Frame pointer. You can also drag a crop handle to define the crop boundary. Corner handles can be used to adjust both the image width and height.

FIG 4.29 Lightroom displays a grid of thirds within the outline to help you compose your final image.

NOTE
After you drag a crop handle, you need to select the Crop Frame tool to use it.

4. Reposition the photo within the crop frame by dragging the photo until you get the desired composition. There are several different grid overlay options available. Press the letter 'o' to cycle through different grid overlays in the crop area.
5. Click the Crop tool or press Enter when you're finished cropping and straightening.

TIP
To limit the display of the grid to cropping, choose View, Tool Overlay, Auto Show. To turn off the grid, choose View, Tool Overlay, Never Show.

Straightening an Image
It happens to all of us at one time or another – a great shot but the camera wasn't level. Straightening an image with Lightroom is a snap. Here is how to do it.

1. In the Develop toolbar, click the Crop Overlay icon, and do one of the following.
2. Select the Straighten tool, and then drag in the photo along a line that you want to be horizontal or vertical. When you release the mouse button, the image straightens as shown in Figure 4.30.

FIG 4.30 After releasing the Straighten tool, a new crop overlay appears to preview the effect of the rotation.

3. If you are satisfied with the straightening, press Enter. To Undo it, use Ctrl+Z (Command Z Mac). Do not use the ESC key to undo a straighten or a crop.

TIP
Holding down Alt (Windows) or Option (Mac OS) with the Straighten tool selected displays a grid that helps you straighten the image.

Some traps to avoid with the Straighten tool. Vertical lines in a building that are near the edge will be distorted by barrel distortion, which is common with most wide angle lenses so try and pick a vertical line nearer to the center. You will have the best success with this tool, if you are less concerned with whether something in truly vertical or horizontal. Look at the entire image. Does it look like it is straight? Some photos can align perfectly with the grid and still look crooked. Your goal is to make the photo look straight not align it with a non-printable grid.

The New Improved Spot Remover

Whether it is a piece of debris on your camera sensor or a pimple, the Remove Spots tool lets you instantly repair a selected area of a photo with a sample from another area. When removing spots, you click on the spot and two connected circles appear: the spot circle indicates which area will change, and the sample circle determines which area of the photo is being used to clone or heal the spot.

1. In the Develop module, select the Remove Spots tool from the toolbar or press the N key.
2. The default setting is Heal. The Heal setting matches the texture, lighting, and shading of the sampled area to the selected area and it does a bang up job of it of making the spot disappear. There will be times when the spot is near a dark or high contrast area. If the Remove Spots tool is set to heal, it will try and blend in the darker colors making something akin to dark smoke. In situations like the one described, use the Clone setting which applies the sampled area of the photo to the selected area – without blending.
3. If the spot you are attempting to remove is larger than your Remove Spots tool circle in the toolbar, drag the Cursor Size slider to make the brush slightly larger than the spot you're removing.
4. Move the Remove Spots tool into the photo and click the part of the photo you want to retouch. In the case of camera sensor spots, it is highly recommended that you zoom in on the image. Sensor spots tend to be soft gray circles that are hard to see when you are zoomed out. The image shown in Figure 4.31 is zoomed in at 100% and shows a sensor spot with the Remove Spot cursor over it.

FIG 4.31 A sensor spot that needs to be removed.

5. After clicking the cursor on the spot two circles appear: the spot circle appears over the selected area, and the sample circle designates the area of the photo used to clone or heal. Where the sample circle ends up varies every time. Lightroom searches the adjacent pixels to find the most appropriate area to use. Sometimes it makes a poor choice and you must drag the sample circle to a different location.

6. If there are more spots on the image (there usually are) press the Space Bar to change the cursor to a Hand tool and pan the image at 100% zoom to find any others that might be lurking in the image.

7. When you are finished, press the N key again and the circles will disappear.

Here are some more suggestions about working with the Remove Spot tool. To select a circle, click it. The selected circle appears thicker than the one that isn't selected. Rather than fiddling with the Spot Size slider in the Toolbar, you can adjust the size of the circles by moving the pointer over the edge of the spot circle until it changes to a double-pointing arrow, and then drag to make both circles larger or smaller. To hide the circles press the H key to toggle the hide and show circles mode. Hold down H for a few seconds to hide the circles until you release the key. It is possible to have a lot of the Remove Spot circles on an image. It is also possible to change your mind about a spot you wanted to remove. To delete a spot, select one of the circles and press Backspace or Delete key. To cancel the Remove Spot operation, click the Reset button in the toolbar. Clicking Reset also removes all previously created spot circles (Figure 4.32).

FIG 4.32 The Remove Spot tool makes the sensor spot disappear.

Getting the Red Out

Removing red-eye using Lightroom's Remove Red Eye tool works most of the time without any problems.

1. After opening an image with red-eye, zoom in (Z) to at least 1:1 (100%) to get a better view.
2. In the Develop module, select the Remove Red Eye tool from the toolbar.
3. Click the center of the eye to use the current selection, or drag from the center of the eye to change the selection size. For best results, select the entire eye, not just the pupil as shown in Figure 4.33.

FIG 4.33 Applying the Remove Red Eye tool.

4. Drag the Pupil Size slider on the toolbar to the right to increase the size of the area corrected.
5. Drag the Darken slider to the right to darken the pupil area within the selection and the iris area outside the selection.
6. Press the H key to hide or show the red-eye circle. To remove the red-eye change, select the red-eye circle and press Enter or Delete.
7. Click Reset to clear the Remove Red Eye tool changes and to turn off the selection. Click the tool again to make further corrections.
8. Move between multiple selected red-eye areas by clicking the selection.

You can almost eliminate red-eye by using an external flash mounted away from the axis of the lens (Figure 4.34). Other tips to avoid red-eye while shooting are avoid taking people's photos in a darkened area or subject who have been drinking alcohol – no kidding.

FIG 4.34 Red-eye is gone.

Showtime: Making Slideshows

You don't go to all the trouble of importing, cataloging, tagging, and cleaning up your photos just so you can increase the size of digital picture collection! You want to *use* your pictures – tell a story, print them, and share them on the Web. And one of the easiest ways to share your pictures is to build a slideshow that you can show on your computer or share with friends. Adobe Photoshop LightRoom makes this easy and fun. You can even add music to your slideshow.

Understanding the Slideshow Module

Like the other modules that have been discussed in this book, the Slideshow module is broken up into several sections (see Figure 5.1). The main section in the center of the screen shows the slide with all the text, shadows, border, and other items you have added to the slide. Other controls enable you to configure these items, add color and background, apply a soundtrack, and preview or play the slideshow. You can even save your configurations as a reusable template.

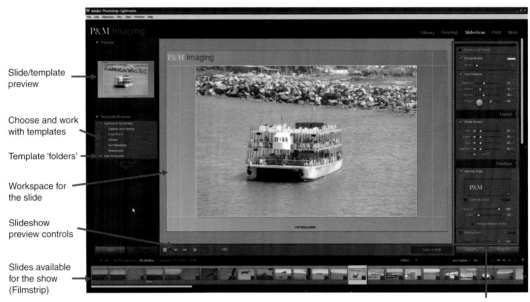

Slide/template preview

Choose and work with templates

Template 'folders'

Workspace for the slide

Slideshow preview controls

Slides available for the show (Filmstrip)

Configure the slideshow

FIG 5.1 Use the controls in the Slideshow module to choose slides, configure, and (of course) perform the show.

NOTE

You can use one of the available templates in the Template Browser as the starting point for your slideshow. Simply select a template before you begin or choose a different template at any time. If you really make a mess of the slideshow, you can start over from the template settings by clicking the template you want to use. This resets everything (background, text overlays, Identity Plate, shadow, etc.) to the template default values.

Selecting and Setting Up for Slideshows

Before you can play your slideshow, you have to set it up. This includes picking the photos to include, configuring how the background will look, adding any informative text you want, and specifying the duration of each slide in the dhow.

Selecting Photos for the Show

The best way to select the photos for your slideshow is to create a collection (as discussed in Chapter 3), then choose the collection in the Library module prior to switching to the Slideshow module. This will make the slides available in the Filmstrip at the bottom of the screen, in the order that you specified when you created the collection. This technique makes it easy to reproduce the slideshow by simply picking the collection and template. It also allows you

to easily rearrange the slides by clicking and dragging the order of the slides in the Filmstrip.

NOTE
You could just select the slides in the Filmstrip prior to previewing or running the slideshow, but you need to perform this task each time you want to run the slideshow.

Configuring the Stroke Border

A stroke border adds a colored border around the entire slide (see Figure 5.2). To add a stroke border, use the Stroke Border control (see Figure 5.3), which is in the options palette on the right side of the screen. Selecting the check box

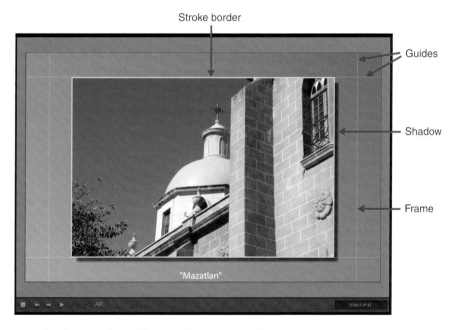

FIG 5.2 A stroke border makes the slide stand out better against the background.

FIG 5.3 Adjust the size and color of the border around with slide with the Stroke Border control.

turns on the stroke border. To change the width of the border (measured in pixels), click and drag the Width slider or type a value into the field. To adjust the color of the stroke border, click the color control to display the Color dialog box. Simply pick the color and click OK.

> **TIP**
> If you hover the mouse pointer over the stroke border width field (but don't click), the pointer turns into a pointing finger with a double-headed arrow. Hold down the left mouse button and drag to the left to decrease the value of the field, or drag to the right to increase the value. This works for all text fields in Adobe Photoshop Lightroom.

Specifying the Shadow

Another way to make the slide stand out from the background is to add a drop shadow behind the slide. The shadow is also visible in Figure 5.2, discussed previously. To cast a shadow behind the slide, select the Cast Shadow check box and use the controls in the Cast Shadow control (see Figure 5.4).

FIG 5.4 Use the shadow controls to adjust the look of the shadow behind the slides.

The controls enable you to do the following:

- *Opacity*: Adjusts the opacity – how much of the background shows through the shadow. Values range from 0% (invisible) to 100% (fully opaque).
- *Offset*: The distance that the shadow is offset from the slide. As the offset grows larger, more of the shadow shows. For example, Figure 5.5 shows two different offsets. The left one is small (40 pixels), while the right one is much larger (100 pixels).
- *Radius*: The radius varies how sharp the corners are as well as feathering at the shadow edges. When set to zero, the shadow has perfectly sharp edges and corners (see the left side of Figure 5.6). When set to a large number (see the right side of Figure 5.6), the corners are rounded and the edge of shadow is feathered.
- *Angle*: This control adjusts the angle between the slide and the shadow. In other words, the source of the 'light' that creates the shadow. For example,

FIG 5.5 A small offset (on the left) looks very different from a large offset (on the right).

FIG 5.6 A small value of radius (on the left) shows sharp corners and edges, while a large value (on the right) feathers the edges and rounds the corners.

if you set the angle to 45 degrees, the source of the light is to the lower left, and the shadow is to the upper right. You can adjust the shadow angle either by clicking and dragging the angle knob, clicking and dragging the slider, or adjusting the value in the text field.

Showing and Adjusting the Guides

The 'guides' provide a visible border which defines the size of the slide image. Moving the guides closer to the edge of the work area increases the size of the central area (frame) in which the slide is visible. You can see the guides in Figure 5.2, discussed previously. To show the guides and adjust their position, select the Show Guides check box and use the Show Guides control panel (see Figure 5.7).

FIG 5.7 Adjust the guides with the Show Guides control panel.

To adjust the position of the guides, you can either click and drag the individual guide sliders (Left, Right, Top, and Bottom) or type a value into the text field for each slider. The value for each slider is the distance (in pixels) from the edge of the work area. You can also click the guide itself and drag it to a new position.

You can either adjust the guides independently or link them together. When you link the guides, adjusting the position of one guide adjusts the position of all the linked guides to the same value. To link any of the guides, click the small square button to the right of the guide name, or click the Link All square button to link them all together at once. All linked guides move together, any unlinked guides can be adjusted independently.

Applying a Color Backdrop

Using an attractive color backdrop for your slides can really make them stand out during a show (see Figure 5.8). The color backdrop actually consists of two parts – the background color and a 'color wash.' These can be turned off and on and controlled independently using the Background Color and Color Wash controls (see Figure 5.9).

To apply a background color, simply click the color bar and specify the color. If you don't add a color wash, the background will be all one color – the color you selected for the background color.

FIG 5.8 A combination of a background color and color wash can make an attractive backdrop for your slides.

FIG 5.9 Use the Background Color and Color Wash controls to specify how the backdrop will look.

To specify the color of the color wash, click the color bar and select the color. How the color wash behaves depends on whether the color wash is used by itself or in combination with the background color.

Using the Color Wash by itself
When you use the color wash by itself (deselect the Background Color check box), it starts at a light color at the starting point, and grows gradually darker as you move away from that point (see Figure 5.10). The starting point is controlled by the Angle control. For example, if the angle is set to 45 degrees, the starting point (lightest color) is in the upper right corner, and the color gets gradually darker as you move toward the lower left. The Opacity slider controls the initial color – the lower the opacity, the darker the starting color.

FIG 5.10 The color wash shows various shades of a single color.

At an opacity of 100%, the starting color is the specified color. At an opacity of 0%, the 'color wash' is simply a black square.

> **TIP**
> The basic background (the one you get if you shut off the background color and color wash) is black. Thus, you can think of the color wash opacity as controlling how much of the black background shows through.

Remember that the most important image on the slide is the slide image, not the background image. If you make the background image too overpowering, it takes away from the slideshow. Instead, choose a background image carefully and use a low opacity (I have found that 25% works well) so that the person viewing the slideshow sees the background image without focusing on it. In addition, choosing a dark background color (the default black works pretty well) keeps the focus away from the image.

Using the Color Wash with a background color

When you use the color wash in combination with the background color (as shown previously in Figure 5.8), the opacity controls how much of the background color is hidden by the color wash. At high values of opacity, the color wash starting point is the specified Color Wash color, and the color wash color and background color are blended together across the background, with the ending point having the pure background color. As you lower the opacity value, more and more of the background shows through – less and less of the color wash color is visible.

Adding a Background Image

You can add an image as a background to all your slides, and adjust the opacity of the image (see Figure 5.11). To do so, select the Background Image check box and drag an image from the Filmstrip to the rectangle in the Background Image controls (see Figure 5.12). The Opacity slider controls how much of the background color shows through – either the default black or the combination of background color and color wash color.

FIG 5.11 Use a background image to set an overall theme for the slides in your slideshow.

FIG 5.12 Specify the background image and opacity with the Background Image controls.

One limitation to placing a background image is that it has to be available in the FilmStrip so that you can drag it to the rectangle in the Background Image controls. If you are using the recommended technique of creating a collection for the slideshow, this means that one of the images will be the background image as well as a slide image. If you don't want this to happen, use the following steps:

1. Create the collection for your slideshow and include the background image in the collection.
2. Switch to the Slideshow module and add the image as a background image by dragging it to the rectangle in the Background Image control.
3. Right-click the image in the Filmstrip and choose Remove from Collection from the shortcut menu.

This removes the background image from the collection (and thus the slideshow), but leaves it available as a background image. Be sure to save the slideshow template (as discussed in the section 'Saving It All as a Template,' later in this chapter).

Zooming to Fit Frame

The section of the slide where image is shown is known as the 'frame.' If you are using guides, the frame is visible as the rectangular section in the middle of the screen, as indicated in Figure 5.2, discussed previously. Unless the frame has the exact same aspect ratio (ratio of the height to the width) as the displayed image, the image won't fill the entire frame (see the upper portion of Figure 5.13). This is especially true with portrait images (images that are taller than they are wide). However, you can force the image to fill the frame by selecting the Zoom to Fill Frame check box at the top of the Options panel on the right side of the screen. This crops (removes portions of) the image to match the aspect ratio of the frame and fill the frame (see the lower portion of Figure 5.13).

Although it is certainly nice to have the image fill the frame, there is a down side – portions of the image must be cropped to make the image fit.

FIG 5.13 The image doesn't fill the entire frame (on the top) unless you choose to zoom to fit frame (on the bottom).

TIP
To position a cropped slide within the frame, click and drag the image in the frame. This enables you to display the portion of the slide you want in the frame.

If you do choose to zoom to fill the frame, use the following steps to exercise the most control over what is removed:

1. Figure out whether most of your slides are portrait (taller than they are wide) format or landscape (wider than they are tall) format. For most people, the most prevalent format is landscape.
2. Adjust the guides and frame to match the aspect ratio of more prevalent format.

NOTE
This assumes that most of your slides will be either uncropped, or cropped to the same aspect ratio (such as the original image aspect ratio). If all your slides are cropped to different aspect ratios, I recommend *not* zooming to fill frame.

3. For slides in the non-prevalent format (usually portrait), either live with the extreme cropping, or create a version of the slide in which the image is centered on a background with the same aspect ratio as the prevalent format. You'll need an image editing program (such as Photoshop Elements) to pull this off.
4. If you decide to create the new version of the slide, import it into Lightroom and replace the original in the collection with the new version.

Adding and Editing the Identity Plate

The Identity Plate (see Figure 5.14) is a special text overlay (see section 'Adding Text to Slides Using Overlays,' later in this chapter) that you can add to the slides.

FIG 5.14 The Identity Plate provides a customizable text overlay.

Adding and configuring the Identity Plate
To configure the Identity Plate, select the Identity Plate check box in the Overlays panel (see Figure 5.15) and use the Identity Plate controls.

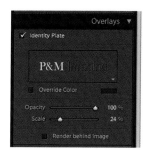

FIG 5.15 Use the Identity Plate controls to configure the properties of the overlay.

The Identity Plate controls enable you to do the following:

- *Change the color*: To override the color of the text, click the Override Color check box, then click the color bar (to the right of the check box), pick a color from the Color dialog box, and click OK. You cannot override the color if you are using a graphic identity plate.
- *Adjust the opacity*: Change the opacity of the text using the Opacity slider or text field. The opacity controls how much of the background color or image shows through the Identity Plate.
- *Change the size/scale*: To change the size of the plate, click and drag the Scale slider or enter a number in the Scale text field. You can also click the Identity Plate, then click and drag one of the sizing handles.

NOTE
Setting the scale to 100% sizes the Identity Plate to stretch completely across the slide.

- *Render behind image*: Normally, the text in the Identity Plate is displayed on the top of the slide image. However, if you want the image to take precedence – hiding the text where the two overlap – select the Render behind image check box.
- *Changing the location*: You can move the Identity Plate to any place on the slide by clicking and dragging it to a new location.

Understanding the anchor point

When you click the Identity Plate (or any other text overlay), you'll notice a small square attached to the text boundary by a dotted line. This is called the 'anchor point.' As you click and drag the Identity Plate (or any other text overlay), the anchor point jumps, automatically relocating to attach itself to either a corner of the slide, the middle of the side of a slide, the corner of the image, or the middle of a side of the image. You can lock the anchor point to prevent it from moving by clicking on it. This turns it into a yellow square with a black dot in the middle.

The anchor point sets the reference between the Identity Plate (or any other text overlay) and the location of the anchor point on the screen. For example, if you set the anchor point to the upper left corner of the image on the slide, it will move as you change images, always maintaining the same distance and angle from the upper left corner of the image. It is usually best to anchor the Identity Plate to a corner or side of the slide because you want it to appear in the same place on the slide. For text overlays, you want it to appear over the image (e.g., the star rating), it is best to anchor to a corner or side of the image, so it remains in the same relative position on the image as the images change during the slideshow.

Creating a custom Identity Plate

You can create your own version of the Identity Plate if you wish, perhaps replacing the default text with your name or the location where the photos were shot.

To create and save a custom graphics Identity Plate, use the following steps:

1. Click the small arrow in the lower right corner of Identity Plate to open the shortcut menu.
2. Choose Edit from the shortcut menu to display the Identity Plate Editor dialog box (see Figure 5.16).

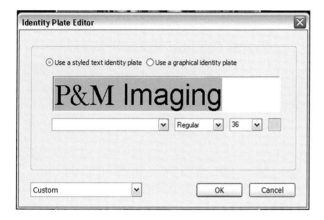

FIG 5.16 Create a custom version of the Identity Plate in this editor dialog box.

3. Click the Use a graphical identity plate radio button.
4. Either click and drag an image onto the graphical area in the dialog box or click the graphical area and pick an image from the Open dialog box.
5. Click the drop-down list in the lower left corner and choose Save As.
6. Fill in the name of the Identity Plate in the Save Identity Plate As dialog box, and click Save.

NOTE
The maximum size of a graphical identity plate is 50 pixels high by 400 pixels wide. If you choose an image that is larger than that, it will be cut off. Note also that although the template does not show the full width of 400 pixels, the actual identity plate (in Lightroom) will show the full width.

To create and save a text identity plate, follow steps 1 and 2 above, then continue as follows:

1. Click the Use a styled text identity plate radio button.
2. Select and edit the text in the identity plate.
3. Select the portion of the text to which you want to apply the changes to the font, style, and size. Use the three drop-down lists to change the font (left), style (middle), and size (right).
4. Select the portion of the text to which you want to apply the changes to the color. Click the color box to the right of the size drop-down box and pick a color from the Color dialog box.
5. Click the drop-down list in the lower left corner and choose Save As.
6. Fill in the name of the Identity Plate in the Save Identity Plate As dialog box, and click Save.

Adding Star Ratings to Your Slides

Adding the rating stars to your slides is simple: just select the Rating Stars check box. You can adjust the opacity and scale using the sliders or text fields, and choose the color by clicking the color box and picking a color from the Color dialog box. You can also adjust the size by clicking the stars and dragging a sizing handle. By default, the stars appear in the upper left corner of the slide, but you can drag them anywhere you want.

Adding Text to Slides Using Overlays

You can add descriptive text to your slides using Text Overlays. Some templates even include common text overlays, such as the photo file name, date, camera, and other metadata. You turn all text overlays on and off using the Text Overlays check box. You cannot make only some text overlays visible – it's all or nothing.

Adding text

To add text to a slide, click the Add text to slide button (ABC). Click the Custom Text button (just to the right of the Add text to slide button) to display the shortcut menu (see Figure 5.17). To pick one of the items in the shortcut menu

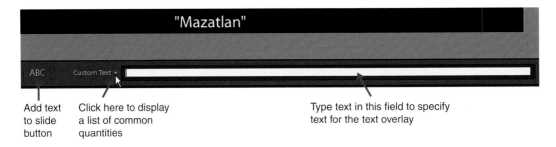

FIG 5.17 Choose an item from the shortcut menu to add that text to the screen.

(such as Date, Equipment, Exposure, and so on) simply choose it from the list. The text is then displayed on the slide (see Figure 5.18).

Another option is to type the text you want into the field to the right of the Custom Text drop-down list. To do so, simply click in the field and type the text, then press Enter.

If you really want to get fancy, choose Edit from the Custom Text drop-down list to open the Text Template Editor (see Figure 5.19). Using this dialog box, you can build a custom text string that includes custom text as well as information about the image (metadata).

FIG 5.18 And here is what the new text might look like.

FIG 5.19 Use the Text Template Editor to create a custom text overlay.

Here is how you can build your custom text string:

• *Start with a Preset*: Choose a preset from the Preset drop-down list at the top of the dialog box. This populates the text box at the top of the dialog box with the contents of that preset. For example, the Date preset places the date field into the text string in the format Month, DD, YYYY.

NOTE
The Example line above the text box displays an example of what the text string will look like. This is not always helpful. For instance, the example of the Metering Mode field simply shows as 'Metering Mode: Pattern.'

123

- *Add a field from the various drop-down lists*: To add a field to the example text, choose the field from one of the 10 drop-down lists in the dialog box. These lists are grouped by the type of data available in the drop-down list, such as the Image Name, Numbering, EXIF Data (metadata about the image conditions) and IPTC Data (metadata that you have provided). Selecting an item from the drop-down list places it into the text string at the location of the text cursor.

NOTE
If you want to add a field that is already visible in the drop-down list, click the Insert button.

TIP
To reposition the text cursor in the text string, click between the fields, which are denoted by braces ({}).

- *Remove a field from the text string*: To remove a field, click it to highlight the entire field – the text between the braces ({}). Then press the Delete key.
- *Change an existing field*: If you want to replace a field in the text string with another field from the original drop-down list, click the field, pause, then click again to display a shortcut menu with the options from the original drop-down list (see Figure 5.20). Then choose a different option.

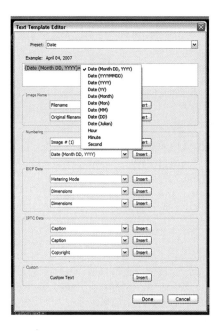

FIG 5.20 Change an existing field to a different field from the original drop-down list you picked the field from.

- *Add custom text*: You can type in any text you want by simply repositioning the text cursor between the fields and typing the text you want. This is a good way to add labels that identify the metadata or to insert spaces between the fields in the text string.

NOTE
You can insert a field labeled 'Custom Text' by clicking on the Custom insert button near the bottom of the dialog box. But I've never discovered a good reason to do so, since you can just click in the text string and type what you want *without* inserting a custom text field.

- *Save the settings to reuse them*: To save the contents of the Text Template Editor so you can reuse them, click the Preset drop-down list and choose Save Current Settings as New Preset. Provide the name in the New Preset dialog box, and click Create.
- *Update an existing Preset*: To update the preset you are currently working with, click the Preset drop-down list and choose Update Preset.
- *Delete a Preset*: To delete a preset, choose Delete Preset (followed by the name) from the drop-down list.

TIP
You'll know that you've modified the existing preset (and thus might want to save the changes) because the name of the preset is followed by '(edited)' in the Preset drop-down list. The Update Preset entry only appears in the drop-down list if you have edited the preset.

Moving and sizing text
Much like the Identity Plate, you can move a text overlay by clicking and dragging it, and text overlays have an anchor point. You can size the text overlay by selecting it and then clicking and dragging a sizing handle. Unlike Identity Plates, however, text overlays do not have a Scale slider, so you must use the sizing handles to modify the size.

Setting the text attributes
Since the text overlays are text, you'd expect that you can adjust the font and face of the text – and you can by using the Text Overlays controls (see Figure 5.21). To change the font, click the existing font to open a list of available fonts and choose a new font from the list. To pick a new face (such as bold, italic, or bolditalic), click the existing face to open a list of available faces and choose a new face from the list.

FIG 5.21 Change the text attributes from the Text Overlays controls.

NOTE
If the list of fonts is too long to display on the screen, click the small arrowhead at the top or bottom of the list to scroll in that direction. You can also press the key for the first letter of the font name if you know which font you want. This jumps right to the set of fonts that begin with that letter.

You can also adjust the opacity using the Opacity slider or text field and change the text color by clicking the color box and choosing a next color from the Color dialog box.

There are two controls you can use which are not in the Text Overlays control section – the rotation controls. These are located in the tools at the bottom of the slide (see Figure 5.22). To rotate the text counter-clockwise, click the left bent arrow or press Ctrl+[. To rotate the text clockwise, click the right bent arrow or press Ctrl+].

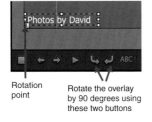

Rotation point

Rotate the overlay by 90 degrees using these two buttons

FIG 5.22 Use the controls at the bottom of the slide to rotate or change the text.

NOTE
The rotation point is the upper left sizing handle – that is, the text box rotates around that sizing handle. The rotation point is indicated by the small black dot in the center of the sizing handle.

TIP
To change the text of an existing text overlay, click the overlay to place the text into the field at the right of the Custom Text drop-down list. Then simply edit the text and press Enter. You cannot, however, edit the text in this field if 'Custom Settings' is visible alongside the ABC button – to change that text, you must choose Edit from the Custom Settings drop-down list and change the text in the Text Template dialog box.

Adding a Sound Track

You can play music with your slideshow, though the configuration options are limited: you can only use MP3 files and you can select only a single folder

that holds the music. The music plays in the order that the files are listed in the folder, so if you don't like the order, you'll need to rename the files to get them into the order that you want.

> **TIP**
> Adding a number in front of the existing file name will do the trick.

To specify the music for the slideshow, use the following steps:

1. Select the Soundtrack check box in the Playback panel on the right side of the screen.
2. Click the text which reads 'Click here to choose a music folder.' This opens the Browse For Folder dialog box (see Figure 5.23).
3. Select the folder from the Browse For Folder dialog box and click OK.

FIG 5.23 Use the Browse For Folder dialog box to pick a folder containing the music files you want to use.

> **NOTE**
> If you have already picked a soundtrack folder, you can change it by clicking on the name of the folder, which replaces the 'Click here to choose a music folder' text.

Saving it all as a Template

After you've gone to all the trouble of configuring everything the way you want, you can save all the settings as a template. Any template you save appears in the Template Browser on the left side of the screen.

To add a template, use the following steps:

1. Click the Add button at the bottom of the Template Browser, choose Slideshow, New Template, or press Ctrl+N.

2. Type the name of the new template into the resulting New Template dialog box.
3. Choose the folder from the Folder drop-down list. The default folder (User Templates) places the new template in the User Templates section of the Template Browser. To create a new folder entry in the Template Browser, choose New Folder from the Folder drop-down list, type the folder name into the resulting New Folder dialog box, and click Create.

TIP
You can also create a new folder by right-clicking on an existing folder (such as Lightroom Templates or User Templates) and choosing New Folder from the shortcut menu. If you prefer to use the menus, choose Slideshow, New Template Folder or press Ctrl+Shift+N.

4. Type the new template name into the New Template dialog box and click Create.

You can change a user template in a variety of ways:

- *Update the settings*: If you change your mind about an item (such as the background color or shadow settings), simply change that item on the slide. Then right-click the template you want to update and choose Update with Current Settings from the shortcut menu.
- *Delete the template*: To delete the template, either choose Delete from the shortcut menu or click the Remove button at the bottom of the Template Browser.
- *Delete a folder*: To delete a folder you have created, select the folder in the Template Browser and either choose Delete Folder from the shortcut menu or click the Remove button. You cannot delete the Lightroom Templates or User Templates folders.
- *Rename the template*: To rename the template, double-click the template in the Template Browser. This makes the template name editable. Change the name and press Enter to finish the job.
- *Export the template*: If you'd like to use this template on another installation of Adobe Photoshop Lightroom, you can export it. To do so, select Export from the shortcut menu to open the Export Template dialog box. Fill in the file name (the default is the template name), navigate to the folder where you want to save the template, and click Save.
- *Import a template*: To import a template, choose Import from the shortcut menu of any user template (in either the User Templates folder or a folder you created). This opens the Import Template dialog box. Choose the template file (it's a file that ends in '.lrtemplate') and click Open to import the template into the same folder as the template from which you chose Import.

NOTE
If you want to import the template into a new folder which contains no templates, choose Import from the folder's shortcut menu. You cannot import templates into the Lightroom Templates folder.

Playing the Show

After doing all the work to set up the slideshow, the payoff comes when you can enjoy the show. You can preview it (which runs the show inside the active area) or play the slideshow in all its full-screen glory – complete with music.

NOTE
Both the preview and slideshow will play in the specified order (order of slides in the Filmstrip) unless you select the Random Order check box in the Playback panel.

Specifying the Slide Duration

You can set the slide duration and the fade duration (the fade effect that occurs between slides) by selecting the Slide Duration check box. Use the Slides slider (or text field) to set the length of time the slide is shown in seconds. Use the Fades slider (or text field) to set the length of time between slides that the fade is shown.

NOTE
If you don't set the Slide Duration, the slides don't advance – only the first slide is shown during the preview or the slideshow. Makes for sort of a boring show!

Viewing the Preview

To view the preview, the first thing you must do is select the slides you want to preview. Your options are:

- *Select a range of slides*: If you select a range of slides, only those slides will play during the preview. You can choose Edit | Select All to select all the images in the Filmstrip.
- *Select a single slide*: This slide will be used as the first slide in the preview or slideshow, and the preview/show will progress from there.
- *Select nothing (Edit | Select None)*: The preview begins with the first slide.

Once you've picked the slides you want to preview, click the Preview Slideshow button, which is located in the lower left corner of the preview area (see Figure 5.24). You can advance quickly through the slides, return to a

Go to previous slide
(or use left arrow)

Preview
slideshow
(turns into
Pause
Slideshow
when
Slideshow
is playing)

Go to first slide
(turns into Stop
Preview
when Preview
is playing)

Go to next slide
(or use right arrow)

FIG 5.24 Use the Preview control buttons to start, pause, advance, and stop a preview.

previous slide, or stop the preview using the rest of the buttons in the lower left corner of the preview area.

You can also control the Preview using keyboard shortcuts and items in the Play menu:

- *Start the preview*: Choose Play | Preview Slideshow or press Alt+Enter.
- *Stop the preview*: Choose Play | End Slideshow or press Esc.
- *Pause the preview*: Choose Play | Pause Slideshow or press the space bar.
- *Restart a paused preview*: Choose Play | Resume Slideshow or press the space bar.

Viewing the Slideshow

There are several options for playing a slideshow as discussed in Table 5.1.

TABLE 5.1 Use these controls to run a slideshow

Slideshow control	What it does				
Play button	The Play button is located near the lower right corner of the screen. Clicking it starts the slideshow. To play just the selected slides, choose Play	Which Photos	Use Selected Photos. If no slides are selected or only a single slide is selected, the slideshow starts from the displayed slide. To play the entire slideshow, choose Play	Which Photos	Use All Available Photos.
Play	Run Slideshow	Selecting this menu option (or pressing the Enter key) runs the slideshow. The options for which slides will get played are identical to pressing the Play button.			
Play	Run Slideshow with all Photos	Selecting this menu option (or pressing Shift+Enter) runs the slideshow with all the photos, ignoring the setting of the Play	Which Photos menu option.		

The Slideshow itself fills the entire screen, so none of the menus are available. Thus, you'll need to pay particular attention to the keyboard shortcuts! Other keyboard shortcuts for controlling the slideshow are:

- *End slideshow*: Press the Esc key or click the left mouse button.
- *Go to next slide*: Right arrow.
- *Go to previous slide*: Left arrow.

- *Pause slideshow*: Space key.
- *Resume paused slideshow*: Space key.

> **TIP**
> You can pick and rank the slides while the slideshow is playing! Simply press the appropriate key (such as 'P' for pick or '4' to rate the slide as 4 stars) while the image is being displayed during the slideshow.

Exporting the Slideshow

If you want people to be able to see your slideshow other than on the computer you built it on, you'll need to export it. To do so, click the Export button near the lower right corner of the screen to open the Export Slideshow to PDF dialog box (see Figure 5.25). The entire set of photos is exported regardless of whether you select a set of photos prior to starting the export.

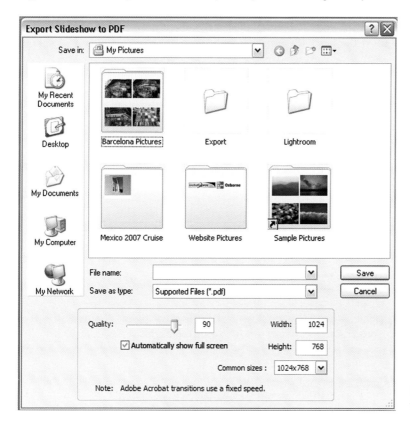

FIG 5.25 Specify the parameters for the Adobe Acrobat (PDF) file export.

> **NOTE**
> A 'PDF' file requires the Adobe Acrobat reader to play it. This is a free download from http://www.Adobe.com.

Type in the file name and set the following parameters in the dialog box (then click Save):

- *Quality*: Use the Quality slider or type a number (between 0 and 100) to set the quality of the exported images. This parameter essentially trades photo quality for file size – higher quality means a larger file.
- *Width and Height*: Set the width and height of the slides in the exported file. You can pick from common sizes in the Common sizes drop-down list, including Screen (your current screen resolution).

TIP
Picking 1024 × 768 is a good compromise for the screen size. Virtually all computers built in the last 10 years can manage this resolution.

- *Automatically show full screen*: Select this check box if you want Adobe Acrobat reader to show the slideshow full screen, without any of the Acrobat menus and controls. Just realize that the people viewing the file must know how to control it (such as pressing Esc to stop the show) without any help from Acrobat menus.

NOTE
The exported slideshow does not contain the music – unfortunately, it plays in silence, even if you have added a soundtrack to the original in Lightroom.

TIP
You can create a slide that contains the keyboard shortcuts for Acrobat, and add that slide as the first slide in your slideshow. That way, people viewing the slideshow in full screen will know how to control it. To build such a slide, you'll need a program like Photoshop Elements which enables you to create image files containing text.

It can take a considerable amount of time to build the PDF file. You can track the progress of the task by watching the progress bar near the upper left corner of the screen (see Figure 5.26). Click the 'x' at the right end of the bar to cancel the task.

FIG 5.26 Watch the progress of the file creation using this progress bar.

Roll the Presses: Printing in Adobe Photoshop Lightroom

S creen-based slideshows are fine for some people, but sooner or later you'll want to print your pictures. Lightroom provides lots of flexibility in configuring to print your work.

Understanding the Print Module

The Print module splits the screen into four main sections as shown in Figure 6.1. You use the middle active area to preview what your printed page will look like.

Selecting and Setting Up for Printing

Setting up for printing involves not only picking the photos to print, but setting all the print parameters, choosing what you want to print, and deciding how big the prints will be. It's important to get this right; otherwise you're wasting money on paper and ink. Unlike a slideshow, there is a penalty for trial and error!

Configuration panels

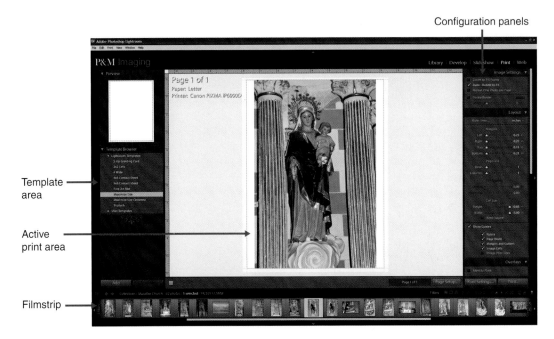

Template area

Active print area

Filmstrip

FIG 6.1 Engage the Print module by choosing Print from the list of modules in the upper right corner.

Selecting Photo(s) to Be Printed

As with the slideshow, it is important to get the photos you want printed into the Filmstrip. From there, if you select only a single photo, only that photo will be printed. If you select multiple photos, they will all be printed. If you don't select any photos, all the photos in the filmstrip will be printed. So be careful and watch the print preview and number of pages in the active area of the screen.

Configuring the Stroke Border

The stroke border (in the Image Settings panel) places a border around the entire photo (see Figure 6.2). To turn on the stroke border, select the Stroke Border check box. You can set the width of the border in 'points' (72 points are an inch) by dragging the Width slider or typing a value into the associated text field. To set the stroke border color, click the color box and choose a color from the Color dialog box.

Setting Units of Measure, Guides, and Showing Rulers

Most of the items in the Layout panel (such as margins, cell spacing, and cell size) need a unit of measure. For example, the margins are measured as a distance from the edge of the paper. You can choose the unit of measure to

FIG 6.2 Create a stroke border all the way around the picture with the Stroke Border control.

use from the Ruler Units drop-down list at the top of the Layout panel. Pick from Inches, Centimeters, Millimeters, Points, or Picas (there are about 6 picas to an inch). All the units in the Layout panel items change to reflect this choice. Oh yeah – the ruler displays in the selected unit of measure as well.

Since the sample print page in the center of the Print module is not shown in full size (unless you have a really big monitor), it is helpful to display the rulers along the top and left edges to let you know how big the images and paper are. To turn the rulers on, make sure the Show Guides check box is selected and then select the Rulers check box.

There are a variety of other guides (see Figure 6.3) that help you do your print layout:

- *Page bleed*: Most printers can't print all the way to the edge of the paper. If your printer is one of these, the page bleed guide will show you the unprintable area. This is helpful in making sure your picture doesn't get cut off at the edges. The page bleed guides are hard to see – they are the very light gray strips around the edges of the page.

Image print sizes Margins and gutters

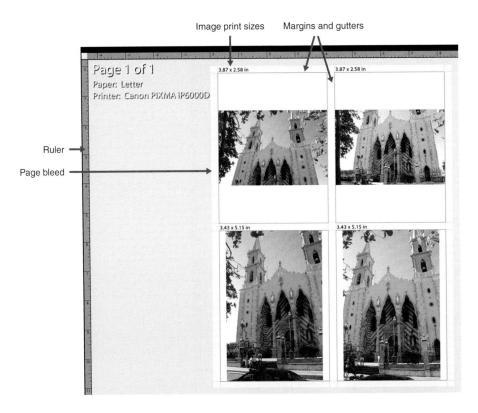

Ruler

Page bleed

FIG 6.3 The rulers and guides provide layout information.

- *Margins and gutters*: These guides show the margins around the edges of the 'image cell' (rectangular area that contains the image). You can adjust the margins as described later in this chapter.
- *Image cells*: These guides show the rectangular area that contains the image, known as the image cell. It doesn't provide any more information than the margins and gutters – it just draws a darker rectangle around the interior of the margins.
- *Image print sizes*: Displays text for the image size in the upper left corner of the image.

Opening the Page Setup Dialog

The Page Setup dialog enables you to pick which printer you want to use (assuming you have more than one), set up some basic properties (such as whether to print portrait or landscape) as well as access the printer properties dialog box to configure that printer. To open the dialog box, click the Print Settings button at the bottom of the configuration panel on the right side of the screen (see Figure 6.4). You can also choose File | Page Setup (or press Ctrl+Shift+P).

FIG 6.4 Configure your printer without having to print by using the Page Setup dialog box.

NOTE
To access your printer's properties, choose your printer from the Name drop-down list and click the Properties button in the Page Setup dialog box.

Dragging or Setting Margins for Border Control

The margins are the spacing around each image cell (the rectangle containing the image). You can adjust the margins as follows:

- Clicking and dragging the appropriate margin slider in the Layout panel (see Figure 6.5). For example, if you drag the Left margin slider to the right, the left margin widens.
- Typing a value into the margin text field, located to the right of the margin slider.
- Clicking and dragging the margin in the preview area. Adjusting the margins this way displays the width of the margin as text in the margin. Adjusting the margins using the sliders does *not* display this measurement.

FIG 6.5 Use the controls in the Layout panel to adjust the width of a margin.

NOTE
The slider and text field display the width of the margins in the selected unit of measure, which you set using the Ruler Units drop-down list, as discussed earlier in this chapter.

As you widen a margin, the image cell (containing the photo) may shrink to keep the correct aspect ratio for the photo. This occurs only if you do *not* choose the Zoom to Fill Frame check box (discussed later in this chapter).

Zoom to Fill Frames

The portion of the paper where image will be printed is known as the 'frame' or the image cell. If you have the Image Cells guide turned on, the frame/image cell is visible as the rectangular section containing the image. Unless the frame has the exact same aspect ratio (ratio of the height to the width) as the displayed image, the image won't fill the entire frame (see the left side of Figure 6.6). This is especially true with portrait images (images that are taller than they are wide). However, you can force the image to fill the frame by selecting the Zoom to Fill Frame check box at the top of the Image Settings panel on the right side of the screen. This crops (removes portions of) the image to match the aspect ratio of the frame and fill the frame (see the right side of Figure 6.6).

FIG 6.6 The image doesn't fill the entire frame (on the left) unless you choose to zoom to fit frame (on the right).

Although it is certainly nice to have the image fill the frame, there is a down side – portions of the image must be cropped to make the image fit.

> **TIP**
> To position a cropped slide within the frame, click and drag the image in the frame. This enables you to display the portion of the slide you want in the frame.

Auto-Rotate to Fit

Some of your photos may not fit the image cell very well. For example, if you are printing just a single large image on a page and that image is landscape (wider than it is tall), it not only won't print very large, but it will leave much of that expensive piece of photo paper blank (see the left side of Figure 6.7). To enable the image to fit the paper better (and thus print larger), you can select the Auto-rotate to Fit check box (see the right side of Figure 6.7).

FIG 6.7 The image wastes lots of paper (on the left) until you rotate it to fit (on the right).

If you'd rather have two smaller versions of the image (see Figure 6.8), you can set the Page Grid Rows to 2 in the Layout panel and select the Repeat One Photo per Page check box in the Image Settings panel (as discussed later in this chapter).

FIG 6.8 There are lots of ways to better use your photo paper – including changing the number of images printed.

Adding Text to Photos Using Overlays

You can add identifying text to your photo by using the options in the Overlays panel. The text will be printed on your photos.

Adding an Identity Plate

To add an Identity Plate to the photo, select the Identity Plate check box in the Overlays panel. As described earlier, you can override the color, choose a different Identity Plate by clicking the arrow in the lower right corner and making a selection, and create a custom Identity Plate by selecting edit from that drop-down list. You can adjust the Identity Plate with the following controls:

- *Adjust the size*: Use the Scale slider or associated text field to adjust the size of the Identity Plate.
- *Adjust the opacity*: Use the Opacity slider or its associated text field. A low opacity gives a 'watermark' effect which enables you to place text (such as a copyright notice) right on the image without obscuring the image too much.
- *Render behind the image*: This check box tells Lightroom to print the Identity Plate only if it is located in a margin – if it falls on top of the image, it will not be printed. Do not use this option if you want to add a watermark as described in the previous option.
- *Render on every image*: This check box tells Lightroom to print the Identity Plate centered on every image. You can't select this check box and the Render behind the image check box at the same time. If you don't select this check box, the Identity Plate is printed just once, in the middle of the page.

Adding photo information

FIG 6.9 Pick the Photo Info to print and the font size.

You can print some information about the photo by selecting the Photo Info check box (see Figure 6.9). To select the information to print, choose it from the drop-down list. Choices include Filename, Date, Equipment, Exposure, and Sequence. You can also choose the Edit option to open the Text Template Editor and construct a custom text string, as described earlier. You can adjust the font size using the Font Size drop-down list just below the Photo Info check box. This font control also determines the size of the items under Page Options.

The information prints in the image cell below the image itself, making the area available for the photo smaller (see Figure 6.10).

Adding page numbers, info, and crop marks

To display the items under Page Options (see Figure 6.11), select the Page Options check box and then select which of the items you want to display:

- *Page Numbers*: Prints the page number on the page. This can be helpful when printing many pages of similar photographs.

FIG 6.10 The photo info prints inside the image cell at the bottom of the image.

Sharpening: Off · **Profile:** (Managed by printer) · **Printer:** Canon PIXMA iP6000D 1

FIG 6.11 Print the Page Options items on the page with these options.

- *Page Info*: Prints some of the Print Job parameters, including the Print Sharpening setting, Profile, and Printer.
- *Crop Marks*: Prints small marks in the margins of the paper to help you cut the margins off using a paper cutter.

Printing Multiple Photos on Single Sheets

Lightroom enables you to print multiple pictures on a single sheet of paper. Thus, you can maximize the use of the paper when printing smaller photos or even 'contact sheets' (many small images on the paper).

Setting Rows and Columns

To specify the number of images printed on a sheet of paper, you can set the number of rows and columns. For example, if you set the number of Rows to 3 and number of Columns to 2, you'll be able to print 6 images (in 6 image cells) on the page (see Figure 6.12).

FIG 6.12 You can print multiple images on a page by adjusting the number of rows and columns.

FIG 6.13 Use the Rows and Columns sliders – as well as cell spacing and cell size sliders – to adjust the number and size of the image cells.

To adjust the number of rows and columns, click and drag the Rows slider or the Columns slider (see Figure 6.13).

You can adjust the distance between the image cells by using the Cell Spacing sliders. The Cell Spacing sliders control the vertical and horizontal spacing between the image cells. For example, in Figure 6.14, the vertical cells spacing has been increased. As you can see, there is more room between the cells than was apparent in Figure 6.13. Another thing to notice is that the height of the cells (see the Height slider value in the Cell Size section) has decreased as the vertical spacing increases. Thus, you can choose to adjust the cell size either directly using the Cell Size sliders or adjust the spacing between the cells using the Cell Spacing sliders.

142

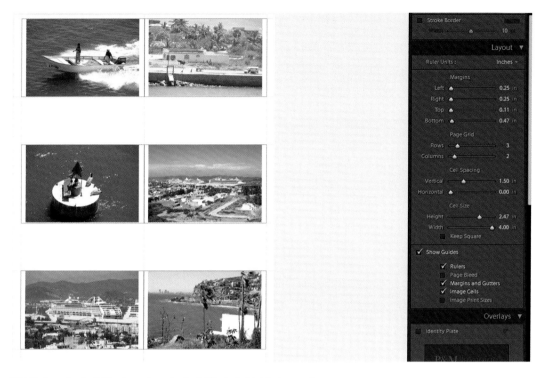

FIG 6.14 Increasing the Cell Spacing or decreasing the Cell Size both shrink the image cell.

NOTE
You can force the image cells to be square by selecting the Keep Square check box. But I am not sure why you'd want to.

Printing the Same Photo Multiple Times on the Same Page

When you print multiple images on a page, a different photo (chosen from the selected photos) is printed in each cell. However, if you want to print the same photo in each cell (e.g., to make a bunch of wallet-size prints), all you need to do is select the Repeat One Photo per Page check box in the Image Settings panel on the right side of the page.

Making a Contact Sheet

A 'contact sheet' is an old photographer's trick. It is very hard to tell what a picture shows when viewing a film negative. So, photographers would lay the strips of negatives on a sheet of photo paper and expose it to light, then develop the photo paper normally. The result is a set of tiny prints, which are far easier to interpret than the negatives. Because the negatives are in contact with the photo paper, the result is called a contact sheet.

Contact sheets are still useful to make a fairly permanent record of the photos in a collection or catalog. To build a contact sheet in Lightroom, you can either set the number of rows and columns you want using the Rows slider and Columns slider or choose one of the contact sheet templates in the Lightroom templates list. There are two common sizes of template available – 4 × 5 (rows × columns) and 5 × 8 (see Figure 6.15).

FIG 6.15 Create a contact sheet using a Contact Sheet template provided in Lightroom.

Saving It All as a Template

As with the other modules in Lightroom, you can save the Print settings in a custom template. This is especially important for the Print module, as there are a lot of settings, including the text, number of rows and columns, margins, guides, and print settings. To create a custom template, click the Add button to open the New Template dialog box and proceed as described in the section 'Saving It All as a Template' in Chapter 5.

> **NOTE**
> The menu options for creating a new template or a new template folder are located in the Print menu (they were located in the Slideshow menu in the Slideshow module).

Configuring for Printing

Now that you've laid out the page and specified exactly what you want to print, you need to configure your printer to get a quality printout. This operation includes setting up color management, possibly choosing a print profile, specifying the print job parameters, configuring your printer, and printing the pages.

Using Color Management

Making sure that the color printed by the printer is accurate can be a somewhat tricky business. This 'color management' can be controlled either by the printer or directly from Lightroom.

> **NOTE**
> You must de-select the Draft Mode Printing check box to be able to specify the color management parameters.

Controlling color management via the printer

The easiest (and usually most accurate) way to perform color management is to allow the printer to control it. To do so, choose Managed by Printer from the Profile drop-down list in the Color Management section of the Print Job panel (see Figure 6.16).

Next, you need to set the type of paper that will be used. How you do this varies somewhat from printer to printer, but normally you can click the Page Setup button or Print Settings button (both of which open the Print Setup dialog box), and click the Properties button (see Figure 6.17). Select the type of paper from the Media Type drop-down list.

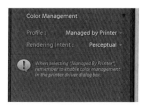

FIG 6.16 Set Color Management to Managed by Printer in the Profile drop-down list.

FIG 6.17 Use the Printer Properties dialog box to set the type of paper and other parameters for printing.

The last step is to ensure that the printer knows it is supposed to manage the color. How you do this is very printer specific. For example, on my HP photo printer, I click the Advanced button in the Printer Properties dialog box to open the Advanced Options dialog box. I then click on the Image Color Management controls (specifically, the ICM Method drop-down list) and choose ICM Handled by Printer.

Controlling color management using a profile

If you'd rather control color management through Lightroom, you'll need to make some different choices. First of all, you'll need to pick the printer profile from the Profile drop-down list (see Figure 6.18).

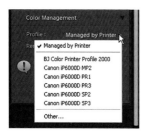

FIG 6.18 Pick a custom profile from the Profile drop-down list.

> **NOTE**
> To read about how to add profiles to this list, see section 'Using the Set Profile dialog box,' later in this chapter.

Next, you'll have to turn off color management on your printer. Again, how you do this varies from printer to printer, and you'll have to consult your manual to find out how. This is very important. If you don't tell the printer not to manage color, both the software and the printer will execute color management – with unpredictable (but usually not good) results.

Using the Set Profile Dialog Box

To install custom profiles in the Profile drop-down list, click the 'Other' entry in the Profile drop-down list. This opens the Set Profile dialog box (see Figure 6.19).

Why would you want to allow Lightroom to control color management via a printer profile? The main reason would be if you wanted to print on special paper or use custom inks that you can't specify via the Printer Properties dialog box. When you purchase these specialized printing supplies, you can often download and install a printer profile specially tuned for your printer from the vendor's web site. To use this custom profile, you must allow Lightroom to manage your color.

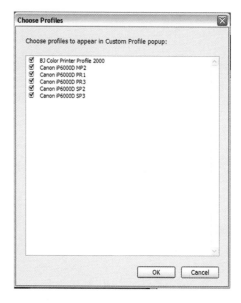

FIG 6.19 Choose the profiles you want to be available in Lightroom from the Choose Profiles dialog box.

Simply click the check box alongside each profile you want to appear in the Profile drop-down list and click OK.

Setting the Rendering Intent

A 'color space' defines how well and how completely an application or a printer handles color. Lightroom uses a very large color space called 'ProPhoto RGB.' This color space can handle pretty much any color you can define on the screen, even highly saturated colors. However, when you want to print, your printer is not able to reproduce all the screen colors because it uses a much smaller color space. The choice of Rendering Intent (in the Print Job panel) determines how your printer will handle the colors which it can't produce (called 'out-of gamut' colors).

There are two choices in the Rendering Intent drop-down list: Perceptual and Relative (see Figure 6.20). Which one you choose is pretty much a matter of taste, but in case you really want to understand how they are different, here it is:

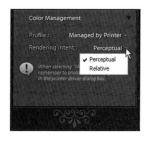

FIG 6.20 Choose the type of rendering from the Rendering Intent drop-down list.

- *Perceptual rendering*: Tries to preserve the visual relationships between the colors. The rendering of in-gamut colors may shift to preserve the relationships to the out-of gamut colors. Since the out-of gamut colors can't be reproduced exactly, the rendering has to use the closest color it does have and change the in-gamut colors to match.
- *Relative rendering*: Reproduces all in-gamut colors and shifts the out-of gamut colors to the closest reproducible color.

Technically, perceptual rendering works best when you have many out-of gamut colors, and relative rendering works best when you have very few out-of gamut colors. But since you rarely know, I find that it is best to try the two and decide which one you like best. Perhaps I am color blind, but I can rarely tell the difference.

Setting Up the Print Job

There are three settings you can choose in the Print Job panel that influence the print quality and details:

- *Draft mode printing*: To set your printer to draft mode, select the Draft Mode Printing check box. Draft mode printing is quick but of low quality. It is a good way to get a quick printout that doesn't have to be great – perhaps a contact sheet. You must de-select Draft Mode Printing in order to enable Print Resolution and Print Sharpening.
- *Print resolution*: You can set the print resolution of the image by selecting the Print Resolution check box and specifying a number (in ppi – pixels per inch). This is handy when you have a high-resolution image because printing at more than 300 ppi simply slows down the printer without increasing the quality of the printed output. By specifying a number between about 220 ppi and 300 ppi, you'll not only get a good quality image, but you'll avoid some of the anomalies (like color banding) that sometimes occur when the image resolution is very high.

NOTE

The Print Resolution has nothing to do with the *printer* resolution. Printers often offer very high-resolution printing, such as 1440 dpi (dots per inch) or higher. The *printer* resolution is a measure of the printer's ability to place tiny dots on the paper to create smooth colors. The *print* resolution measures the actual pixels per inch of the image. For example, if I have an image that measures 2400 pixels wide by 3000 pixels high and I want to print that image at 4 × 5 (inches), the resolution will be about 600 ppi. Some printers (especially snapshot printers) will actually produce poorer results than they would at 300 ppi. Thus, you can tell Lightroom to scale the image and output 300 ppi and you'll actually get better results.

- *Print sharpening*: If you don't sharpen an image when printing, it may come out a little fuzzy. Thus, sharpening is usually a good idea. You can set the amount of sharpening by selecting the Print Sharpening check box and picking a value (Low, Medium, or High) from the drop-down list.

Setting Up for Printing (Printer Dependent)

Every printer has a Printer Properties dialog box, and each one is a little different. We've already seen the Printer Properties dialog box for my Canon Photo printer, Figure 6.21 shows the Advanced Options dialog box for my HP photo printer (where you perform color management on the printer).

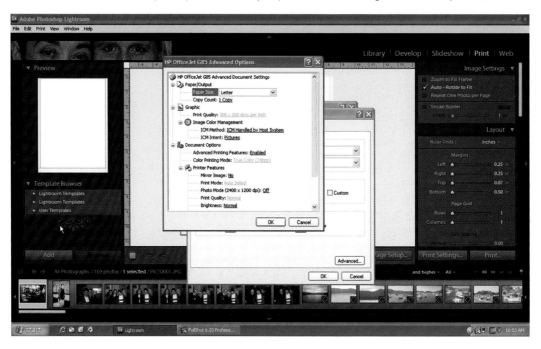

FIG 6.21 The Advanced Options dialog box for my HP photo printer.

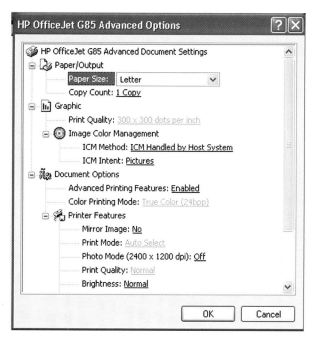

FIG 6.21 (Continued)

The last step before printing is to make sure that all the properties are set appropriately. These may include the paper and color management (discussed previously), printing resolution, scaling of the image, layout, paper source, and even automatic adjustments such as brightness and color saturation (depending on your printer).

Printing a Photo

When all is said and done, the last step is to actually print the pages. To do so, use the following steps:

1. Click the Print button or choose File | Print (Ctrl+P).
2. View the Print dialog box one last time to make sure everything is set correctly.
3. Click OK to send the job to the printer.

> **NOTE**
> If you want to print in just one step, select File | Print One Copy (Ctrl+Alt+P).

Web Wizard: Creating and Posting Images on the Web

We've discussed sharing your photos by creating a slideshow and by printing them out. The last way that Adobe Photoshop Lightroom enables you to share your work is via the Web. Using the Web module, you can create a standard (HTML) photo gallery or a Flash photo gallery and post the gallery on your web site. A variety of different templates are available to help you work efficiently.

Understanding the Web module

The Web module, like the other Lightroom modules, divides the screen into three main areas (in addition to the Filmstrip): the Preview area and Template Browser (on the left), the active area where you configure the web pages, and the Layout panel (on the right) where you set your options and configure the details of the site (see Figure 7.1).

The active area in the middle of the screen is always 'live,' that is, as you build your web pages, you can click the links and choose photos, and the live area will behave pretty much like a browser would. For example, if you select a thumbnail of an image, the full image appears in the window (see Figure 7.2). This feature makes building your web photo gallery very interactive.

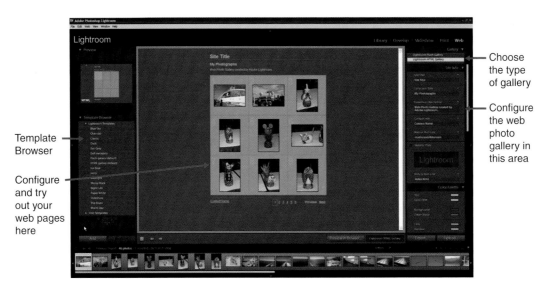

Choose
the type
of gallery

Configure
the web
photo
gallery in
this area

Template
Browser

Configure
and try
out your
web pages
here

FIG 7.1 The Web module is laid out much like the other Lightroom modules.

Navigation controls

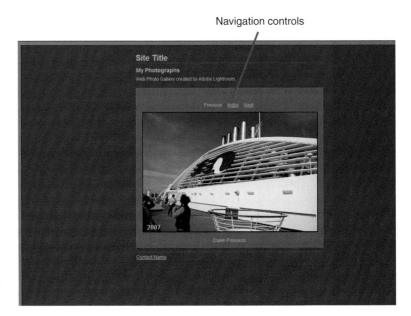

FIG 7.2 If you click a photo
thumbnail, you'll see the photo, along
with the navigation controls.

TIP
Click on the large version of the image to return to the index page
(showing the thumbnails).

Selecting and Setting Up for the Web

To establish the basic layout and configuration of your web photo gallery, pick a template from the Template Browser on the left side of the screen. From there, you can use the controls on the right side to select the type of gallery you want to build and customize all its components.

Selecting Photo(s) for Your Site

As with the Slideshow module, you need to pick the photos you want to post on your web site. The cleanest way is to create a collection and select it before switching to the Web module. However, you can select photos in the Filmstrip and choose Web | Which Photos | Use Selected Photos if you just want to create web pages from the selected photos. To switch back to using all the available photos, choose Web | Which Photos | Use All Available Photos.

Choosing Between Flash and HTML Galleries

Lightroom enables you to build two types of galleries – Flash galleries and HTML galleries. An HTML gallery performs the basics – showing thumbnails (which link to the larger version of the image), providing navigation controls to move between the photo pages, and displaying text labels. A person viewing the web site doesn't need anything extra besides their browser. Another advantage is that you can open the HTML web pages in an HTML editor and customize them further – perhaps by adding additional text, logos, and links to other pages on the web site.

A Flash web site has many of these same attributes, but adds dynamic special effects, such as image fades in and out, changing the thumbnail border color when you hover the mouse over it, and more. However, you don't have as much control over the size of the large images as you do with HTML and previewing your web pages in a browser can take quite a while as Lightroom builds everything necessary to perform that task. Also, the browser must have the appropriate Flash Player plug-in installed to view the Flash gallery. If you don't have the Flash Player, you'll get a warning and a link to allow you to download it. In addition, if you have the security setting set to block scripts and ActiveX controls, you'll get the warning (a yellow bar near the top of the screen in Internet Explorer).

> **NOTE**
> To allow the Flash gallery to play in Internet Explorer, click the yellow warning bar and select 'Allow Blocked Content.'

The available templates are designed for either HTML or Flash, and you'll need to pick a template that is suitable for the type of gallery you want to build. Most of the template names don't give you clue as to which type of gallery they are for. However, if you hover the mouse pointer over a template name, the Preview

153

FIG 7.3 The script 'f' indicates that this template is designed for Flash.

at the top will tell you. If the preview shows 'HTML' in the lower left corner, the template is designed for HTML. If the preview shows a stylized script 'f' in the lower left corner (see **Figure 7.3**), the template is designed for Flash.

NOTE
If you choose to build an HTML gallery and then pick a Flash template, the gallery choice changes to Flash automatically (and vice versa).

Setting the Site Info

The text fields located in the Site Info panel on the right side of the screen enable you to customize the text that appears on photo gallery web pages. To enter a value in each field, click the field, type in the text, and press Enter.

TIP
If you don't want a particular field to appear on the web page, leave it blank.

The Web or Mail Link field works a little differently than the other fields in the Site Info panel. The value you enter in this field is used as a hyperlink for the Contact Name. What actually occurs when the contact name is clicked on depends on what you put in the Web or Mail Link field:

- *mailto*: 'mailto:' followed by a valid email address. This will open the user's email program with the To: line already addressed to the specified email address. If you'd like the subject line to be populated as well, add a space and 'subject=' followed by the subject line.
- *Web address*: Typing in a valid web address (such as http://www.dplotkin.com) will open the specified web page in the user's browser.

Each text label has a small arrow to the right of the field title. Click this arrow to display a drop-down list of any values you previously typed into this field for any Web presentation. To pick a value from the list, simply click on it.

Adding an Identity Plate

If you wish, you can add an Identity Plate to the thumbnail pages and detail pages. Creating and editing the Identity Plate works exactly as described earlier in Chapter 5. For an HTML gallery you can add a Web or mail hyperlink to the Identity Plate by specifying the email address or web address in the Web or Mail Link text field. If the user clicks on the Identity Plate, their email application (for an email address) or browser (for a web address) will open to display the link.

NOTE
The Identity Plate appears in the Site Info panel for an HTML gallery, and the Appearance panel for a Flash gallery.

Configuring the Color Palette

You have considerable control over the color palette used to render your web pages. The color controls (located in the Color Palette panel on the right side of the screen) vary depending on whether you are using a Flash gallery or an HTML gallery.

Configuring the color palette for a Flash gallery

Table 7.1 summarizes the palette controls for a Flash gallery, as shown in Figure 7.4.

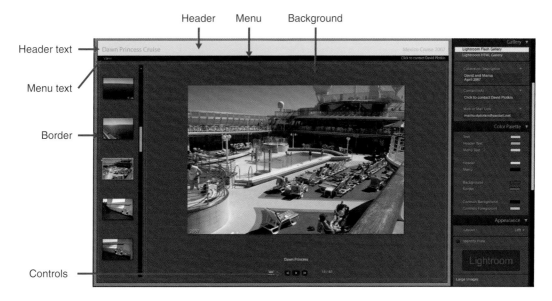

FIG 7.4 You have considerable control over the colors used in a Flash gallery.

TABLE 7.1 Use the color palette controls to configure a Flash gallery

Palette control	Sets the color of:
Text	Text in the main photo area, such as the photo title
Header text	Larger 'header' text near the top of the screen
Menu text	Smaller 'clickable' text that triggers a hyperlink or displays a menu. In Figure 7.4, this includes the contact name near the top right corner and the View menu near the top left corner
Header	The area behind the header text
Menu	The area behind the menu text
Background	Overall background color – the color of any area not overridden by other palette controls

(Continued)

155

TABLE 7.1 (Continued)

Palette control	Sets the color of:
Border	The border around the main photo area and the thumbnail area.
Controls background	The area behind the controls
Controls foreground	The slideshow controls (such as those near the bottom of the screen in Figure 7.4)

Configuring the color palette for an HTML gallery

Table 7.2 summarizes the palette controls for an HTML gallery, as shown in Figure 7.5 and 7.6.

TABLE 7.2 Use a different set of color palette controls to configure the colors in an HTML gallery

Palette control	Sets the color of:
Text	General text, such as the site title, collection title, collection description, contact name, and the page controls near the bottom right corner
Detail text	The text that appears on the 'detail page' – the page which appears if you click on a thumbnail and displays the larger version of the image. This text includes the page controls on the detail page, such as the Next, Previous, and Index hyperlinks (see Figure 7.6)
Background	Overall background color – the color of any area not overridden by other palette controls
Detail matte	The frame (matte) color around the larger image on the detail page (see Figure 7.6)
Cells	The individual 'cells' which contain the thumbnails
Rollover	The individual cells when you move the mouse over the cell. Doing this changes the color to the Rollover color
Grid lines	The grid lines that separate the cells
Numbers	The numbers that appear in the individual cells. You can turn the cell numbers on by selecting the Show Cell Numbers check box in the Appearance panel

Setting the Web Page Appearance

As with the color palette, the Appearance control vary depending on whether you are building a Flash gallery or an HTML gallery (Figure 7.6).

Configuring the appearance for a Flash gallery

In addition to turning the Identity Plate on and off, the Appearance controls for a Flash gallery (see Figure 7.7) enable you to change the sizes of the large image and thumbnails, as well as the layout.

Grid line Cell number Section border

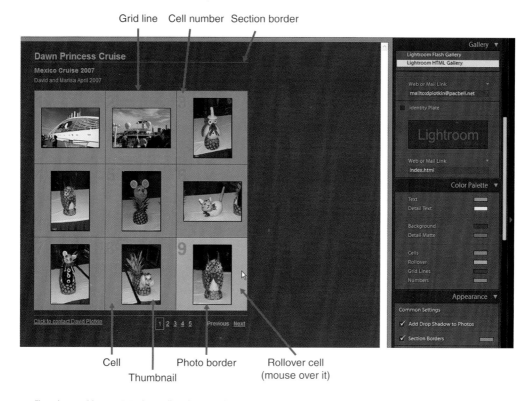

Cell Photo border Rollover cell
 (mouse over it)
 Thumbnail

FIG 7.5 The index page(s) in an HTML photo gallery shows the thumbnails.

Text

Section border

Detail text

Detail matte

Photo border

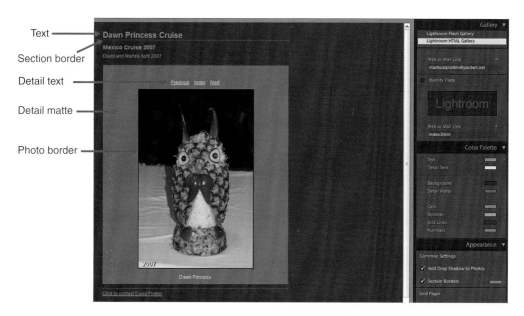

FIG 7.6 Clicking a thumbnail takes you to the image detail page, which displays a larger version of the image.

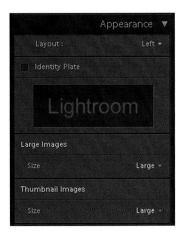

FIG 7.7 Use the Appearance panel to adjust the image sizes and overall gallery layout.

To adjust the image sizes for the gallery, use the following options:

- *Large images size*: Choose a size (Extra Large, Large, Medium, or Small) from the Large Images Size drop list.
- *Thumbnail size*: Use the Thumbnail Images Size drop-down list to select a thumbnail size (from Extra Large to Small). Larger thumbnails (which are exported as image files) show you more information about the image before you click on it – but take up more space on the screen and take longer to load.

The values in the Layout drop-down list make a big difference in how the Flash photo gallery is laid out. The options are:

- *Scrolling*: This option places the thumbnails in a horizontal row below the larger image. Use the scroll bar below the thumbnails to scroll through them (see Figure 7.8). As with all the layouts, you can use the page controls below the larger image to move through them one by one.
- *Paginated*: Places the thumbnails in multiple columns to the left side of the larger image. There is no scroll bar provided, instead, you must use the page controls below the thumbnails to view another page of thumbnails (see Figure 7.9).
- *Left*: Places a vertical row of thumbnails to the left of the larger image. Use the scroll bar to the right of the thumbnails to scroll through them (see Figure 7.4).
- *Slideshow only*: Displays only the larger image and controls to move through the images (see Figure 7.10).

Configuring the appearance for an HTML gallery
The Appearance panel (see Figure 7.11) for an HTML gallery provides a set of controls to change how the web page looks. The most powerful control is the Rows and Columns grid. To change the number of rows and columns, hover

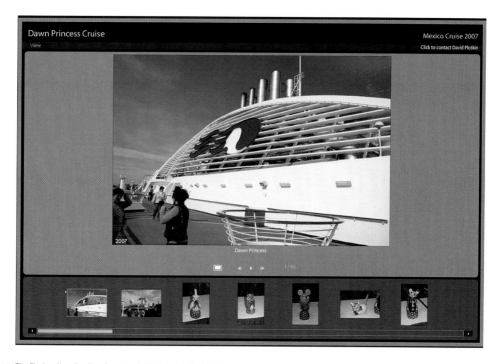

FIG 7.8 The Flash gallery Scrolling layout puts the thumbnails at the bottom.

FIG 7.9 The Flash gallery Paginated layout puts the thumbnails to the left.

FIG 7.10 The Flash gallery Slideshow Only layout hides the thumbnails altogether.

the mouse pointer over the grid and position it so that the number of rows and columns you want is highlighted, then click. You can see the highlighted grid in Figure 7.11.

The rest of the controls are broken up into three sections:

- *Common Settings*: The common settings apply to both the thumbnail pages and the large image (detail) pages. You can add drop shadows to photos and thumbnails by selecting the Add Drop Shadow to Photos check box. You can also enable section borders (select the Section Borders check box) and set the section border color (click the color rectangle and pick a color from the Color dialog box).
- *Grid Pages*: These settings apply to the thumbnails pages. In addition to the Rows and Columns grid, you can choose to show cell numbers (select the Show Cell Numbers check box). You can also enable photo borders (select the Photo Borders check box) and set the photo borders color (click the color rectangle and pick a color from the Color dialog box). You can see these items detailed in Figure 7.5, discussed previously.
- *Image Pages*: These settings apply to the pages that show the large images. To set the size of the large image in pixels, use the Size slider or the associated text field. You can turn the photo borders on for the large images by selecting the Photo Borders check box. In addition, you can adjust the border width using the Width slider (or its associated text field) and select

If you click here, you'll have 4 columns and 3 rows of thumbnail cells

FIG 7.11 Use the Appearance panel to set the number of rows and columns, and turn on various dividers and borders.

the photo border color by clicking the color rectangle and picking a color from the Color dialog box. You can see these detailed items in Figure 7.6, discussed previously.

NOTE
Unlike a Flash gallery, you can't directly adjust the thumbnail size in an HTML gallery. The thumbnail size is set by the number of rows and columns, which sets the size of each 'cell' containing a thumbnail.

Adding Image Info

The Image Info panel enables you to configure the Title and Caption fields that appear in various templates. To include the title or caption with an image, select the Title or Caption check box. To pick an item to include for the title or caption, you can either choose one of the options in the drop-down list alongside each field, or select Edit from the drop-down list to open the Text Template editor and create a custom text string, as discussed in Chapter 5.

Setting Up the Output

The Output Settings panel enables you to specify and configure items like size of images and quality.

The Output Settings panel (see Figure 7.12) enables you to adjust the following output settings:

- *Metadata*: When the image is exported to the web site, you have the option of including the information about the image (called metadata) with the

FIG 7.12 Use the Output Settings panel to set the size and quality of exported image.

image. People who open the image in a viewer can see most or all of the included metadata (depending on the viewer they use). You have two options about how much of the metadata to include: just the copyright or all of the metadata. You can specify the values for the metadata in the Metadata panel of the Library module.
- *Large image quality*: You can vary the quality of the large image between 0 and 100 using the Quality slider or the associated text field. Higher quality images look better but the files are larger and take longer to download.
- *Add copyright watermark*: If you select this check box, the image is constructed with a copyright notice embedded as a faint 'watermark' so it is visible to anyone viewing the image.

Saving it all as a Template

As described in Chapter 5, you can save all your selections as a template. This saves the layout, colors, and selections. The template you save is either set up for an HTML gallery or a Flash gallery, depending on the type of gallery you were using when you created and saved the template.

> **TIP**
> You might want to include the type of gallery in the template name, for example, 'HTML Brightly Colored.'

Previewing and Exporting Your Photo Gallery

Although the active section in the center of the Web module gives you a pretty good idea of what the web photo gallery will look like, you can only really see how viewers will see it if you preview the site in your default browser.

Previewing Your Gallery in a Browser

To preview your gallery in a browser, click the Preview in Browser button or choose Web | Preview in Browser (or press Ctrl+Alt+P). This creates a set of files and web pages locally on your hard drive and opens the first web page in your browser (see Figure 7.13). From this page you can navigate to other pages, view the larger images, and test out the photo gallery functionality before going to the trouble of uploading the gallery to your web site.

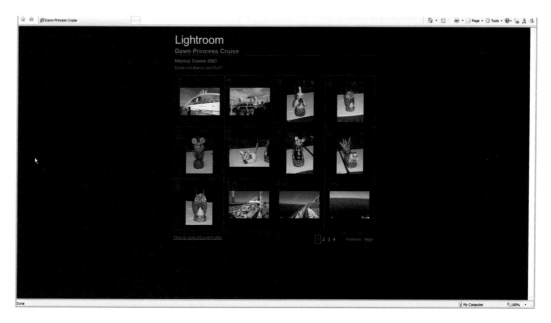

FIG 7.13 Get a good look at your gallery in your web browser.

It can take a while to build the preview and open it in your browser. While Lightroom is building the preview, you can watch the progress in the upper left corner of the screen (see Figure 7.14). The small thumbnail shows you the image that is currently being converted, and the progress bar shows you how far you have to go. If you change your mind and want to cancel the preview, click the small 'x' at the right end of the progress bar.

FIG 7.14 Watch the progress toward being able to preview your gallery in this progress bar.

TIP
While viewing your HTML photo gallery, you can click on a large image to return to the thumbnail page containing that image. This works when you post the gallery on the Web, too.

Exporting Your Gallery

Once you are happy with your photo gallery, you can export it to your hard drive. This enables you to view the gallery in a browser on your local machine whenever you want, without having to use the rather lengthy Preview in Browser process every time. It also enables you to modify the generated web pages using a web page editing program before uploading them to your web site. Further, if you design your web site locally on your machine with a program like FrontPage or DreamWeaver (and many others), you can import the photo gallery into the local copy of your web site and then upload (publish) it from there.

To export your web site, click the Export button (near the lower right corner of the screen), choose Web | Export Web Photo Gallery, or press Ctrl+J. This opens the Save Web Gallery dialog box, where you can navigate to the folder where you want the exported files to be placed, enter a file name, and press Save. Lightroom uses the supplied file name to create a subfolder in which it places all the folders, web page files, images, and support files necessary to view or publish your photo gallery. As with Preview in Browser, it can take a while to generate everything, so you can watch the progress in the progress bar at the upper left corner of the screen.

Once the export is complete, you can view the photo gallery in your browser by navigating to the folder and subfolder where you placed the files, and double-clicking on the Index.html file to open it in your browser.

WARNING
The 'home' file for the photo gallery is always called 'Index.html' and you cannot change that. It is very likely that the home page for your web site is *also* called Index.html. Thus, if you upload your photo gallery to your web site using an FTP program, you must locate the photo gallery inside its own folder on the web site. Otherwise, the page Index.html from the photo gallery will overwrite the home page of your web site, which is not normally what you want.

Posting Your Photo Gallery

Of course, you probably did all this work so you can post your photos on your web site and share them with the world. Lightroom enables you to do that from within the program. Doing so isn't much different from uploading other

types of files to your web site using your Web-building program – you just need to set up the FTP settings.

Configuring Your FTP Settings

To upload the photo gallery files to your web site, you need to supply the FTP parameters. To specify them, click the entry alongside the FTP Server field in the Output panel to display the drop-down list. Initially, this list will have only two entries – Custom Settings and Edit. Click Edit to open the FTP File Transfer dialog box (see **Figure 7.15**). The various parameters should have been supplied to you by the company providing your web site, so fill these into the various fields in the dialog box. To save the settings as a new preset, choose Save Current Setting as New Preset from the Preset drop-down list, fill in the name of the preset in the New Preset dialog box, and click the Create button. From then on, the name of your preset will appear in the FTP Server drop-down list in the Output panel.

FIG 7.15 Fill in the FTP settings that enable files to be uploaded to your web site.

NOTE
If you fill in the password and select the Store password in preset check box, you will not be prompted for your password when you upload the gallery to your web site. If you do *not* select the check box, you'll be prompted for your password each time you upload a gallery.

It is crucial that you select the Put in Subfolder check box in the Output panel and supply the name of the subfolder. If you don't do this, the base page for your gallery (remember, it is called Index.html) will be uploaded to the main (root) directory of your web site. As noted in the earlier warning, if your web site home page is also called Index.html, the photo gallery will write over your web site home page.

Performing the Upload

To send your photo gallery to your web site, click the Upload button. If you didn't save your password in the FTP Server preset, you'll be prompted for it. Lightroom then begins creating the web site (watch the progress with the progress bar in the upper left corner of the screen) and uploads it to your web site via FTP.

Extra Stuff You Need to do on Your Web Site

Once you have performed the upload, your photo gallery exists as a set of files on your web site. However, people visiting your web site won't know it is there! In order to help them find it, you need to add links to the pages on your web site so that visitors can click those links and view your photo gallery. In addition, you should provide a way to return to your web site's home page from the photo gallery thumbnail pages so that site visitors aren't 'trapped' in the photo gallery.

Adding links to your web pages

To add links to the photo gallery, you need to know the location of the photo gallery index pages. For both an HTML photo gallery and a Flash photo gallery, the initial view page is called Index.html, and it is located inside the subfolder you specified in the Output section of the Web module prior to uploading the files. For an HTML photo gallery there is an 'Index' page for each page of thumbnails inside the 'content' folder (which is inside the specified subfolder). Thus, if there are four pages of thumbnails, you'll find Index.html, Index_1.html, Index_2.html, and Index_3.html. The version of Index.html located inside the content folder is identical to the version of Index.html located inside the gallery's subfolder.

> **NOTE**
> The mechanism for how you add links to your web pages depends on what Web-building software you use. But if you are already using this software to build your web site, you should be familiar with that.

At a minimum, you'll want to add a link to one of the Index.html pages from your web pages. If you have multiple photo galleries (each in their own subfolder), you might want to create a page in your web site that lists them all, with each item in the list linked to an Index.html page in a photo gallery (see **Figure 7.16** to see how this might look).

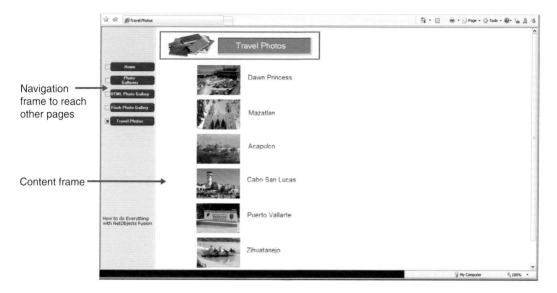

Navigation frame to reach other pages

Content frame

FIG 7.16 List multiple photo galleries on a page in your web site to provide a quick link to them.

> **TIP**
> You can use one of the photo gallery thumbnails as the link to that gallery's Index.html page. For an HTML gallery, the thumbnails are stored in the folder content/bin/images/thumb. For a Flash gallery, the thumbnails are stored in bin/images/thumb.

Providing a way to return to your main web site

Once a visitor is viewing the photo gallery pages, they should have a graceful way to return to the other pages in your web site. Otherwise, they might be forced to reenter the web address to get back to the home page. There are several ways you can implement this on your web site:

- *Use frames*: If your web software supports it, you can use frames. Frames provide (at a minimum) two areas on your web site – one where you can make links always available and one where you view the content (see Figure 7.16 for an example). You can add links to the photo gallery in the 'link frame' (shown on the left in Figure 7.16). And, since the photo from the gallery is viewed in the content frame (just to the right of the link frame) and the link frame is always available, your site visitor can move to another page just by picking a link from the link frame.
- *Edit the photo gallery index pages*: You can use your Web editing software to add links to each Index page. These links enable the site visitor to jump to another page in the web site. A good example would be linking back to the page with the list of photo gallery pages, if you use one.

- *Trick Lightroom*: If you recall, Lightroom actually provides a link on each page – the 'Web or Mail Link' in the Site Info panel. This link is intended to either open an email editor (mailto:) or a web page. Simply enter the web address (URL) that you would like the site visitor to be able to jump to (e.g., the page with the list of photo galleries) in the Web or Mail Link field. Then, instead of putting a name in the Contact Info field, put in something like 'Return to Photo Galleries List.'

INDEX

A

Add copyright watermark 162
Adobe Photo Downloader 24, 25, 26
Anchor point 120
Aperture 1
Appearance control
 for Flash gallery 156–158
 for HTML gallery 158–161
Apple 8, 12
Auto Hide 15
Auto Hide & Show 15
Auto-rotate to Fit check box 138
Autorotation 37
Auto Tone button 80

B

Background color 114
 Color wash with 116
Background image 116–117
Basic panel, of develop module 90, 92
Browse For Folder dialog box 127

C

Camera 68, 82
 Getting photos, to Lightroom 23–24
 Import settings 24–26
Card readers 23–24
Catalog:
 Exporting 3, 68–69
 Importing 3, 69–74
Cell Size sliders 142
Cell Spacing sliders 142
Change Zoom icon 37
Color backdrop 114
 Color wash 115–116
Color Label Set 44
Color Labels 42
 Photos without 48
 Working with 44–46
Color management control
 via Printer 145–146
 Using profile 146
Color palette:
 for Flash gallery 155
 for HTML gallery 156
Color space 147
Color Temperature 80–82

Color wash 115
 with Background color 116
Column slider 142
Commencement, of Photoshop 1
Common settings 160
Comparing photos, in Lightroom 38–40
Configuring, for printing
 Color management usage 145–146
 Print job, setting 147
 Printer Properties dialog box 148
 Rendering Intent, setting 147
 Set Profile dialog box usage 146–147
Contact sheet 143–144
Create and open catalog 3
Create Collection dialog box 57
Crop Frame pointer 101
Crop Marks 141
Crop Overlay 101, 103
Crop Ratio box 83
Custom graphics Identity Plate 121
Custom Text Overlay Creation 123

D

Detail panel 99
Develop module 5, 90–99
 Compare View 91
 Interactive Histogram 90–91
 Preset powers 99
 Split Toning 96–99
 Tone Curve panel 93–96
 White Balance 91–93
Develop presets 78
Develop setting 30–32, 73
Digital Asset Management (DAM) system ix–x
Digital camera 2, 51
Digital image management ix
Digital negative (DNG) 4, 28–29
Draft Mode Printing check box 147
Duplicate image method 7

F

Fades slider 129
Feature, of Lightroom 7–8
Filmstrip 15
Flags 43–44
Flash gallery 153–154
 Appearance control 156–158

Flash gallery (*Continued*)
 Options 158
 Paginated layout 159
 Palette control 155
 Scrolling layout 159
 Slideshow Only layout 160
Flaws, Retouching and correcting
 Image Cropping 101–102
 Image Straightening 102–103
 Remove Red Eye tool 106–107
 Remove Spots tools 104–105
Folder Pane 52, 56
Format 68
Frames 118, 138, 167
 See also Image Cells
FTP setting 165

G
Graphic accelerator, *See* Video graphics cards
Grid pages 160

H
Hardware and performance, of Lightroom
 Mac vs. PC 8
 Networking and shared resources 11–12
 Random Access Memory 10–11
 Speed, need for 8
 Video graphics cards 8–9
 Wacom tablet 11
 Windows Vista, view of 11
Heal setting 104
History, of Lightroom 2–3
HSL/Color/Grayscale panel 94
HTML gallery 153–154, 156, 167
 Appearance control 158–161
 Palette control for 156

I
Identity Plate 13, 125, 140, 154
 Adding and configuring 119–120
 Adding and editing 119
 Anchor point 120
 Color palette, configuring 154–156
 Custom identity plate creation 121–122
 Custom version creation, in editor dialog
 box 121
Image cells 136, 137, 138
 See also Frames
Image correction 80
Image Info panel 161
Image management concepts, of Lightroom:
 Collections 56–57
 Quick Collections (QCs) 56, 58
 Stacks 52–55
Image pages 160–161

Image print sizes 136
Images, creating and posting on web 151
Import Dialog box 24, 28, 29, 70
Import from Catalog dialog box 70, 71, 72
 Existing image 72–74
 New image 71
Import from Lightroom Catalog dialog box 70
Import setting, for Lightroom 24–26
Importing photos 78
 Backup to 30
 Copy to 29
 Develop Setting 30–32
 File Handling 28–29
 File naming 30
 Import button 33
 Keywords 32–33
 Metadata 32
 Organize 29
 Show Preview 29
 Standard-sized previews, rendering 33
 Suspected duplicate, re-importing 30
Impromptu Slideshow 49, 85
Index page:
 Editing 167
 in HTML photo gallery 157, 166
Index.html. 164, 165, 166
Interactive Histogram 90–91

K
Keyboard shortcuts, for Lightroom 16–21
Keyword Stamper tool 4
Keyword Tags panel 59, 60, 62, 67
Keyword Thumbnail 60
Keywording panel 60, 62
Keywords 32–33, 59
 Auto completion 64
 and Case 61–62
 Drag and drop method 62
 List, maintenance of 64–65
 Metadata browsing 67–68
 Painter tool 65
 to Photos, adding 60–61
 Power of sets 62–63
 Searching 67

L
Lens 68
Lens Correction panel 99
Library 3, 12, 14, 65, 66, 68

M
Mac 8, 75–76
Mac OS X 11
Mac vs. PC 8
Mailto 154

Margins and gutters 136
Metadata 4, 32, 72, 162
 Access Keyword Set command 63
 browsing 67–68, 72, 162
 Color Label Set 44
 Keyword Set 63
 panel 4
 presets 32
 Purge Unused Keywords 65
Modules, of Lightroom 12
Multiple photo printing, on single sheet 141
 Contact sheet, making 143–144
 Rows and columns, setting 142

N
Navigating and managing Lightroom 12
 Filmstrip 15
 Grid view/Image Display 13–14
 Hiding panel option 15–16
 Keyboard shortcuts, power of 16–21
 Left panel 15
 Main menu 13
 Right panel 14
 Tool bar 14
 Top panel 13
Navigator panel 37, 92
Negative files 73
Network attached storage (NAS) drive
 11, 74
Network shared drives 74
New develop setting 5
New Template dialog box 144

O
Organizing photos:
 Exporting catalog 68–69
 File storage, in light room 75–76
 Image management concepts 52–58
 Importing catalog 69–74
 Keywords, power of 59–68
 Network shared drives and Lightroom 74
Out-of gamut colors 147
Output Settings panel 161–162
Overlays panel:
 Identity Plate, adding 140
 Page option check box 140–141
 Photo information, adding 140

P
Page bleed 135
Page info 141
Page numbers 140
Page Setup dialog 136–137
Painter tool 4, 65–67
Perceptual rendering 147

Perfection, pursuing:
 Develop module 90–99
 Quick Develop panel 78–89
 Retouching and correcting flaws 101–107
Photo gallery, posting 164
 Extra stuff 166
 FTP file transfer dialog box 165
 Homecoming 167
 Upload button 166
Photo gallery, previewing and exporting of 162
 Exporting 164
 Preview in browser button 163
Photos, into Lightroom:
 from Camera 23–26
 Checklist, before importing 26–27
 Comparing 38–40
 Drag and drop 34
 Importing, See Importing photos
 Organizing, See Organizing photos
 Rating 41–49
 Sorting the good 36–37
 Speed bumps 34–35
Photoshop vs. Lightroom 6–7
Predefined keyword set 63
Print resolution check box 147
Print sharpening check box 147
Printing:
 Auto-rotate to Fit check box 138–139
 Border control 137
 Configuration, See Configuring, for printing
 Module 133
 Multiple photos, on single sheet 141–144
 New Template dialog box 144
 Overlays panel 140–141
 Page Setup dialog 136–137
 Photo 149
 Photos, selecting 134
 Stroke Border check box 134
 Units setting 134–135
 Zoom to Fill Frames check box 138
ProPhoto RGB 147
Purge Unused Keywords 66

Q
Quick Collection (QC) 56, 58
Quick develop panel 78
 Tone Control portion 86–90

R
Random Access Memory (RAM) 9–10
Rating photos, in Lightroom 41
 Color Labels 44–46, 48
 Filtering 46–48
 Flags 43–44
 Stars 42

Index

Rating Stars check box 122
Relative rendering 147
Remove Red Eye tool 5, 106
Remove Spot tool 5, 105
Rendering Intent drop-down list 147
Repeat One Photo per Page check box 139, 143
Row slider 142
Rows and Columns grid 158
Ruler Units drop-down list 135
Rulers check box 135

S
Save Quick Collection dialog box 59
Save Web Gallery dialog box 164
Script 'f' 154
Show Guides check box 114, 135
Sidecar file 7
Site Info panel 154
Slides slider 129
Slideshow playing 130–131
 Exporting 131–132
 Preview 129–130
 Slide duration, specification 129
Slideshows:
 Background image, adding 116–117
 Cast Shadow control 112–113
 Color backdrop, applying 114–116
 Duration 129
 Exporting 131–132
 Guides, showing and adjusting of 114
 Identity plate, adding and editing
 of 119–122
 Module 109
 Photos, selecting 110–111
 Preview 129–131
 Rating stars 122
 Stroke border 111–112
 Template Browser 127
 Text overlays 122–127
 Zooming to Fit Frame check box 118–119
Speed bumps, Lightroom 34–35
Split Toning panel 96–99
Stacks 52–55
 Commands for 56
Stars, working with 42
Stroke Border 111–112, 134
Survey View 40
Synchronize folders 4
Synchronize Setting dialog box 84–85
Synonyms 59–60

T
Target Adjustment tool (TAT) 94
Template Browser 127–129
Template panels 4

Text Identity Plate 121
Text Overlays, for slides 120, 122, 126
 Adding text 122–125
 Moving and sizing text 125
 Sound track, adding 126–127
 Template Browser 127–129
 Text attribute, setting 125–126
Text Template Editor 123, 125, 140
Tone Controls, of Quick develop pane 78,
 86–90
 Blacks 88
 Brightness 88
 Clarity 88
 Contrast 88
 Exposure 86
 Fill Light 86–88
 Recovery 86
 Saturation 88–89
 Vibrance 88
Tone Curve panel 93–96
Trick Lightroom 168

V
Video graphics cards 8–9
Virtual copy indicator 73

W
Wacom tablet 11
Web address 154
Web, creating and posting images on:
 Appearance control 156–161
 Flash gallery 153–154
 HTML gallery 153–154
 Identity plate, adding 154–156
 Image info panel 161
 Links, adding 166
 Module 151
 Output Settings panel 161–162
 Photo gallery, posting 164–168
 Photo gallery, previewing and exporting
 of 162–164
 Photos, selecting 153
 Site Info panel 154
 Template, saving as 162
Web module 151
White Balance 78, 82, 84, 89, 91–93
Windows 75
Windows Action dialog 25
Windows Vista 11
Workflow, of light room 6
Working message, on image 38

Z
Zoom to Fill Frames check box 138
Zooming to Fit Frame check box 118